IMAGES
of America

GLENDALE

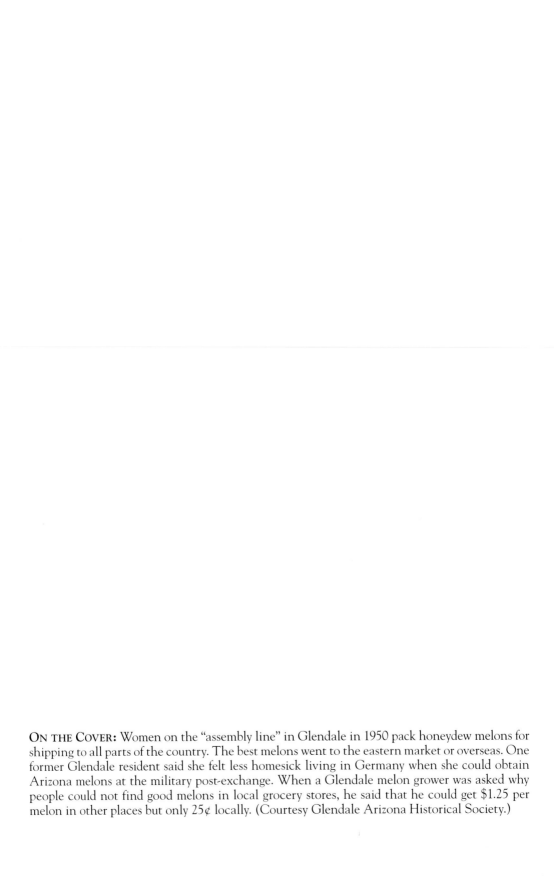

ON THE COVER: Women on the "assembly line" in Glendale in 1950 pack honeydew melons for shipping to all parts of the country. The best melons went to the eastern market or overseas. One former Glendale resident said she felt less homesick living in Germany when she could obtain Arizona melons at the military post-exchange. When a Glendale melon grower was asked why people could not find good melons in local grocery stores, he said that he could get $1.25 per melon in other places but only 25¢ locally. (Courtesy Glendale Arizona Historical Society.)

IMAGES
of America

GLENDALE

Carol J. Coffelt St. Clair and
Charles S. St. Clair

Arizona Historical Foundation

ARCADIA
PUBLISHING

Published by Arcadia Publishing
Charleston SC, Chicago IL, Portsmouth NH, San Francisco CA

Printed in the United States of America

Library of Congress Catalog Card Number: 2006930228

For all general information contact Arcadia Publishing at:
Telephone 843-853-2070
Fax 843-853-0044
E-mail sales@arcadiapublishing.com
For customer service and orders:
Toll-Free 1-888-313-2665

Visit us on the Internet at www.arcadiapublishing.com

*To Ryan, Dustin, and Jason in hopes that their generation will continue
to preserve the past for future generations.*

CONTENTS

Acknowledgments

All of the images in this book are from the collection of the Glendale Arizona Historical Society. Over the years, many individuals and groups have shared their family photographs with the historical society, either by donating photographs or by allowing their photographs to be copied. The City of Glendale, the Glendale Chamber of Commerce, Glendale Elementary School District #40, and local photographers Byron Shaw, Cecil Prather, and Richard Gilmore have made significant contributions of photographs to the historical society's collection. In addition, we wish to thank Ruth Byrne and Nancy McKay for their help in verifying some of the facts recorded here.

Finally, thanks to Dr. Jack August of the Arizona Historical Foundation in Tempe, Arizona, for encouraging us to write this book.

INTRODUCTION

Central Arizona and the Salt River Valley—the Valley of the Sun—was a hot, dry desert unsuitable for agriculture until the Arizona Canal was completed in the spring of 1885. The impetus to develop a canal system was the Desert Land Act enacted by Congress in 1877. This act provided for a section of land (640 acres) to be granted to qualified persons. Without water, however, the land was useless. To provide water, the Arizona Canal Company was formed with the goal of building a canal from the Salt River on the east, across the northern part of the Valley to the Agua Fria River on the west. To pull off this enormous construction feat, the company contracted with William J. Murphy. A Civil War veteran and a railroad contractor, Murphy took on the job of securing financing for the canal as well as the job of building the canal. It took the labor of hundreds of men and over 200 mule teams working for two years to build the 42-mile-long canal, but when it was finished, the Valley had a water supply adequate to irrigate nearly 100,000 acres. With water available, the area was poised for development.

Murphy and other investors set up the Arizona Improvement Company in 1887 and acquired thousands of acres of land in the Valley by purchasing them and filing claims under the Desert Land Act. Over the next several years, they sold this land to farmers and other settlers. Many of these new desert dwellers were invited to come to Arizona Territory by Murphy himself, for he traveled and advertised widely to promote the area for which he and his investors had land and water to offer to potential settlers.

Settlers, however, needed more than just land and water. They needed towns with businesses that could provide goods and services to them. The first such community in the Northwest Valley was Peoria. Named after Peoria, Illinois, former home of some of the founders, the town was staked out in 1888. Within a few years, other towns, such as Marinette, Glendale, Ingleside, and others, were laid out and promoted by the Arizona Improvement Company.

Not everyone who came to this area bought land from a land speculator. Many of the early settlers took advantage of the Desert Land Act to acquire land in the soon-to-be Glendale area. Two Peoria, Illinois, brothers, William and Samuel Bartlett, who were very successful commodities brokers, each acquired a section of land. William named his homestead Rancho del Sahuaro, or Sahuaro Ranch. His brother named his homestead Rancho del Higo, or Ranch of the Figs. The brothers looked upon their ranches as business investments rather than as places to live. They were not settlers. Those who managed and worked the land for the Bartletts were the settlers.

Sahuaro Ranch was established as an experimental ranch growing figs, pears, oranges, peaches, apricots, olives, grapes, grains, alfalfa, and other agricultural products. The first permanent building was an adobe house, built in 1887 to serve as home and office for Stephen Campbell, the first superintendent of Sahuaro Ranch and also brother-in-law to William Bartlett. Campbell, a retired banker who moved to the ranch for his health, lived in a tent until completion of the adobe. He managed the ranch from 1886 until 1890, made the first improvements, and set out the first fruit orchards. Campbell died in 1890, and William Bartlett hired local rancher Harry Adams to oversee Sahuaro Ranch.

The fig orchards started producing in 1891. So in the summer, before harvesting the fruit, Bartlett had a fruit-packing house built near the adobe. It was designed to be "fly tight," and it was there that they dried and packaged figs and other fruits for shipping around the country. Practically from the beginning, both Sahuaro Ranch and Rancho del Higo were cited far and wide as models of successful irrigation farming in the Valley.

Meanwhile, Murphy was busy in the East and Midwest promoting and praising the Valley area for farming and raising families. He invited settlers to "colonize the land" south of the Arizona Canal and plant their farms in this future agricultural promised land. Murphy arranged to present his story of the West and its virtues to various religious groups through their newsletters, such as the *Gospel Messenger*, and at annual meeting get-togethers. In 1891, a group of Brethren (German Baptists) from the Midwest, another group of Brethren (River Brethren) from California, and some families from Pennsylvania were convinced to come to the Valley to set up a farming community. An added enticement was the planned town of Glendale. In 1892, just two miles south of Sahuaro Ranch and two miles west of Del Higo Ranch, Burgess A. Hadsell laid out the town site of Glendale.

Glendale was established as an agricultural community for "quiet, sober, industrious, hardworking people." It was to be a temperance colony with property owners being prohibited by deed restrictions from making or selling alcoholic beverages. As one widely circulated advertisement of 1892 described Glendale, there were "School Houses and Churches, But no saloons or gambling houses! No drunken brawls! No jails! and no paupers!"

One

THE EARLY YEARS

The story of Glendale begins with construction of the Arizona Canal, started in 1883 and completed in 1885, and the distribution system to move water from the canal south to the farms and ranches of landholders who were entitled to water. Twenty feeder canals, called "laterals," spaced a mile apart across the Valley, were dug to carry water from the Arizona Canal. Before this water distribution system was constructed, the Glendale area was mostly uninhabited desert. The early success of Sahuaro Ranch and other large ranches in the Glendale area that used irrigation farming did much to bolster the claims of land speculators that the Valley could become an agricultural paradise. In 1895, however, a flood washed out the headgates of the canal, making it impossible to regulate the flow of water into the canal. It took many months to repair the damage, but before repairs were completed, a three-year drought hit the Valley starting in 1897. The unpredictable flow of water in the canal left many ranches with dying crops and orchards. Some of the earliest Brethren settlers left for greener pastures in California, but other farmers replaced them. Surmounting the difficulties of desert living, most Glendale residents remained in their growing, developing town.

By 1895, Glendale counted 300 residents in town and there was a new two-story brick grammar school for the community's 50 pupils. The Santa Fe, Prescott, and Phoenix Railway was laying track through town parallel to Grand Avenue, the road built in 1888 to connect Northwest Valley communities to Phoenix. The Brethren, Methodist, and Catholic churches were organized, and others would follow. By the early 1900s, the town had a library, a woman's club (the Self Culture Club), a lumber and hardware business, and several agricultural support businesses such as warehouses, a shipping depot, and a sugar-processing plant. Perhaps the largest operation in town was the sugar beet processing plant (locally known as the Sugar Beet Factory) built by the Eastern Sugar Company in 1906 at a cost of $1 million. At the time it was built, the factory was described as "the greatest single industrial enterprise" in the Valley. Many enthusiastically dubbed Glendale "Sugar City."

William J. Murphy undertook construction of the Arizona Canal in 1883 without knowing the extent of the formidable engineering and financing problems he would encounter. Nevertheless, in May 1885, with the job finished, he watched the first water flowing through the canal. In 1888, Murphy built Grand Avenue on a straight diagonal from Phoenix to Peoria, Arizona. It passed through the area about to become the town of Glendale and provided an important transportation link for all of the northwest Salt River Valley.

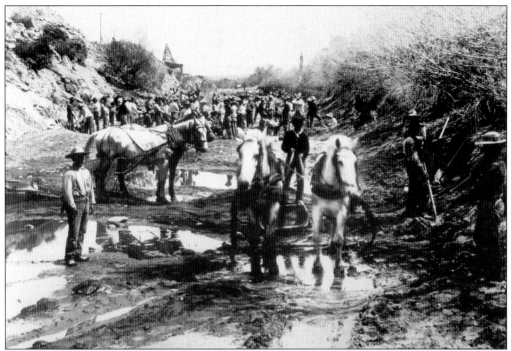

Because of the growth of weeds and tree roots in and along the Arizona Canal and its laterals, it was a never-ending job to clean the canals so water would flow freely to the irrigated fields. Crews were hired to regularly clean out the ditches and canals. Following heavy rains, repairs would be necessary. During World War II, German prisoners of war held at Papago Park in Phoenix were used to clean the laterals in Glendale and other West Valley towns.

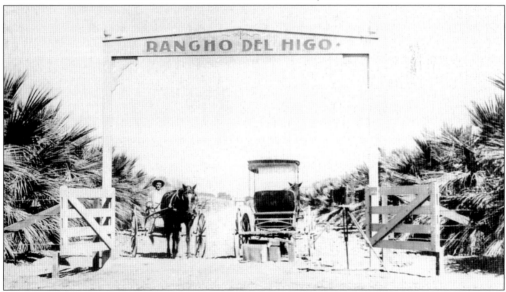

One of the earliest agricultural operations in the Glendale area was Samuel Bartlett's 640-acre Rancho del Higo. Like his brother's Sahuaro Ranch nearby, Sam's Rancho del Higo was hailed as proof of the success of irrigation farming in the Salt River Valley. Although the ranch is gone, some of the palm trees that were at the entrance are still standing at Forty-seventh and Northern Avenues.

William Henry Bartlett was born in Peoria, Illinois, in 1850. He was the son of a prominent merchant and descended from a distinguished New Hampshire family. After graduating from Dartmouth College in 1871, he joined his brother Samuel's grain commission business in Peoria and was instrumental in its growth into a large successful operation with offices in half a dozen Midwest cities. In 1875, he married Mary Wentworth Campbell, and they had three children. Bartlett's interest in the Salt River Valley was kindled by land promoters visiting in the Midwest. In the 1880s, he acquired the section of land that he christened Sahuaro Ranch. Managing it from Illinois through a trusted foreman, Bartlett developed a substantial farming and ranching operation. In the summer of 1898, he considered moving permanently to his "rustic ranch" in Arizona. Instead he settled in northeastern New Mexico where he developed Vermeijo Park Ranch. Bartlett retired from the hustle and bustle of the commodities business in 1912. He sold Sahuaro Ranch in 1913. For the rest of his life, he devoted his time to his New Mexico ranch. He died in December 1918.

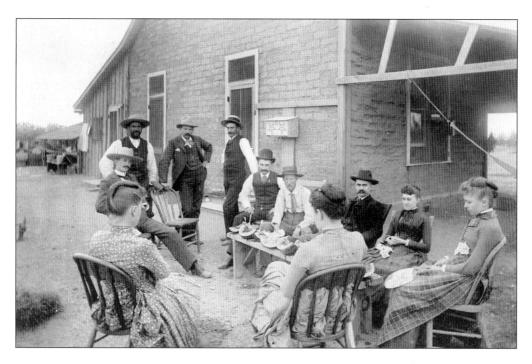

Next to the two-room adobe house at Sahuaro Ranch in the late 1880s, visitors enjoy a feast of freshly picked melons in the above image. Although the guests are unidentified, it is likely that one of the men has land for sale. Sahuaro Ranch was a prime "excursion" destination for potential land investors. William J. Murphy and other developers would show off the ranch and its bounty in hopes of making a sale to the visitors. Today restored Sahuaro Ranch retains much of its turn-of-the-century charm on the 17 acres of the original ranch that were converted into a historical area park. On the left in the image below are the 1930 garage, the 1898 bedroom addition, and the 1892–1895 main house (the adobe house is left of the garage, not pictured).

Burgess A. Hadsell was a well-known colonizer for the German Reformed Church, whose members were often referred to as Dunkards or Brethren. In the fall of 1891, Hadsell convinced some 70 families, including 33 of his relatives, to move to Arizona Territory to the virgin lands of the temperance colony of Glendale. As a result, in the spring and summer of 1892 the new community became home to many new settlers.

This newspaper advertisement from the *Arizona Weekly Gazette* in 1892 invites temperance-minded people to settle in Glendale. William J. Murphy and other investors circulated similar advertisements widely in the Midwest and East. The original plat for Glendale was registered November 2, 1892. The next year, on May 8, Burgess Hadsell registered an addition to the town site, which he called Hadsell's Addition. As this property was sold, the deeds carried a clause prohibiting the manufacture or sale of alcohol.

☀ GLENDALE ☀

ATTENTION IS CALLED TO THE

Temperance Colony of Glendale.

The location is made upon the choicest fruit lands of the valley. No more beautiful site could be selected. The town is well planned for convenience and beauty.

BROAD AVENUES, PUBLIC SQUARES, AND LARGE LOTS

→ THE SALE OF INTOXICANTS ←

IS FOREVER FORBIDDEN

IN THE CONVEYANCE OF THE LAND.

School Houses and Churches,

But no saloons or gambling houses! No drunken brawls! No jails! and no paupers!

The design is to furnish opportunities for BEAUTIFUL, PEACEFUL HOMES, combining as fully as possible the advantages of the city with the security and quiet and charm of the country. This will be appreciated by a very large class of people. It is the First Colony located in the territory, planned on this basis.

Address:—GLENDALE COLONY CO.,
PHŒNIX, A. T.

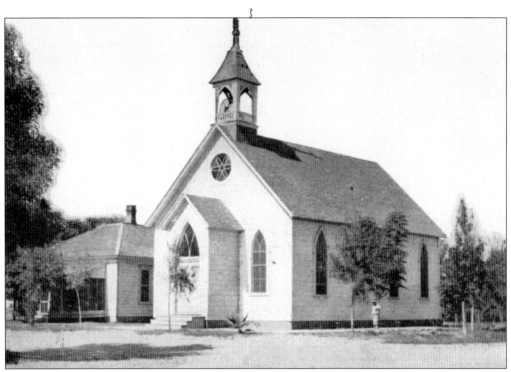

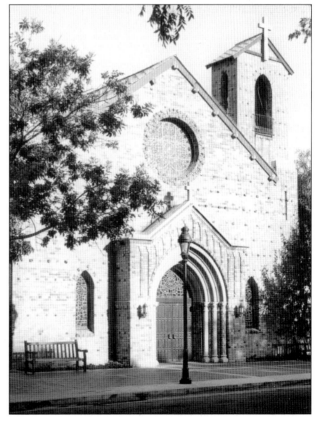

Built in 1897, the Methodist Episcopal Church (above) was used until 1920 when, anticipating building a new church, the sanctuary was sold to the Seventh-Day Adventists. In March 1920, the building was moved to another location, and the parsonage (on the left in the above image) was moved to another part of the property to make room for the new church. The cornerstone, engraved April 6, 1920, was not laid until May 4, 1923. Nevertheless, the foundation was completed by June 1920. The boy by the tree is Howard Twitty. Construction problems, materials delays, and financial woes delayed completion of the new church (below) until 1928. A formal dedication was held on February 3, 1929. When the church again needed space to expand, the parsonage was moved north to Second Avenue (Fifty-eighth Avenue), where today it is an antique shop.

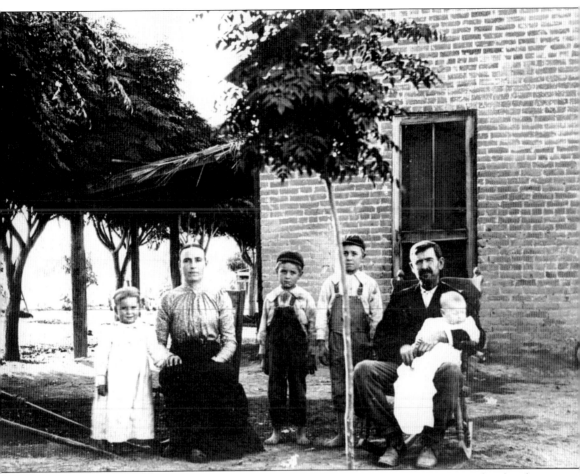

This early Brethren family, the Coffelts, came to Glendale by train in 1898. In 1903, they lived in this one-room brick house located near where the Glendale Union High School athletic stadium was built in 1947. There is a screen door on the entrance and covered porches on two sides of the house, although only one porch is seen in the image. Palm frond–covered porches, as seen here, were often a part of early Glendale houses. Not only did the porches provide some shade during the day, they also served as sleeping porches at night during the hot summers. It was a common practice to move a wood-burning cooking stove outside during the hot months. The Coffelt family are, from left to right, Pearl, Mary "Mollie," William "Bill," Lee, James "J. H.," and baby George. Later, three other children, Albert "Bo," Luella, and Donna, were born to Mollie and J. H.

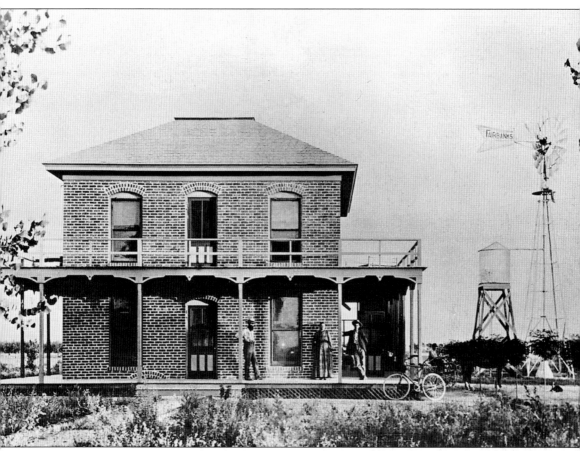

The Henry and Catherine Lehman home on west "C" Avenue (west Myrtle) gives a glimpse of how some people lived in early Glendale. Built before 1900, the home has gone through many changes over time, including fire, rebuilding, and remodeling, but it is still standing today. Henry Lehman was the first president of the Glendale State Bank, founded in 1909. His son, Ray Lehman, worked the family farm where he kept a small dairy herd. Belle Lehman, Ray's wife, sold raw milk to many Glendale families until a Valley fever scare in 1940. The windmill (right) and water storage tank seen in this 1909 photograph were one source of water in the arid desert.

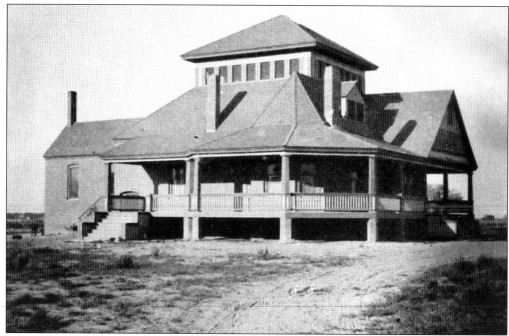

Known as the Hamilton House, this 17-room late Queen Anne–style house was built by Wisconsin lumberman Herbert W. Hamilton for his family, on 318 acres of land a mile north of downtown Glendale. Begun in August 1897, it was completed by Christmas Day, when the Hamilton family arrived in Glendale. Hamilton raised cattle in partnership with his former Wisconsin partner, Harry W. Adams. Hamilton and his wife, Ida, were socially active in the community, but for some reason they moved away. By 1903, the Hamilton's had left Glendale and moved to Eureka, California, where Hamilton returned to the lumber business. In 1907, Louis Marshall Sands, a Michigan lumberman, purchased the home and property for $46,000 and renamed it Manistee Ranch for his hometown in Michigan. The above image depicts the ranch house as it appeared in December 1897, and the image below shows it in 1992.

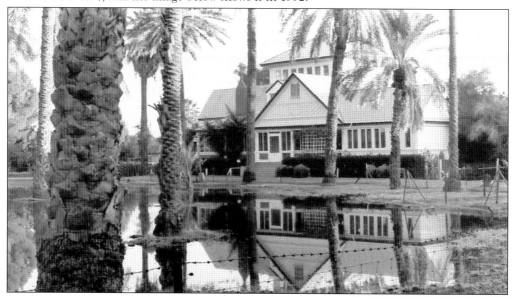

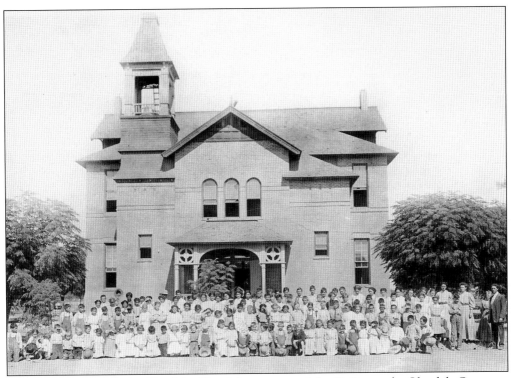

Built in 1895 of locally fired brick by Glendale contractor John B. Doner, the Glendale Grammar School enrolled 50 students the first year. By 1900, this four-room schoolhouse served more than 100. This building was the pride of Glendale for several years, but the Sugar Beet Factory supplanted it in popularity after 1906.

GLENDALE PUBLIC LIBRARY

Cert. No. 6
No. Shares 1
Amount $ 5⁰⁰

Glendale, Arizona,

This is to Certify, that ___E E Jack___
is the owner of 1 Shares of the value of Five Dollars each, in the Glendale Public Library Association, and is entitled to all the privileges of membership as provided in the Constitution and By-Laws of the Association.

Secretary

President

This Certificate is not transferable.

The Glendale Public Library Association was formed to help support the fledgling library started by Vic Messenger in 1897. For $5, Edgar E. Jack, superintendent of Rancho del Higo, purchased one share in the public library, as evidenced by this certificate No. 6 dated January 1, 1898. Messenger, as secretary of the association, endorsed it, as did the association president, Harry W. Adams, who was superintendent of Sahuaro Ranch.

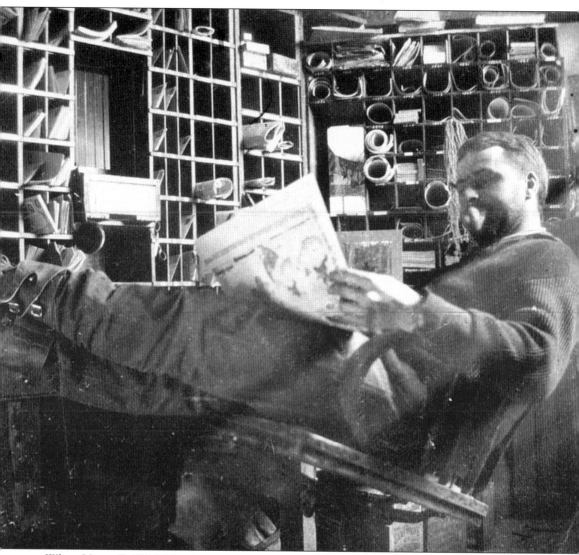

When Victor E. "Vic" Messinger came to town in the 1890s, he went to work as a manager for Ryder's Lumber and Hardware Company. After "Teddy" Roosevelt's election as president of the United States in 1904, Vic was appointed to the part-time position of postmaster for Glendale. In 1910, after Glendale was incorporated, he became the first town clerk. Messinger's most lasting contribution to Glendale, however, was starting the public library. In 1897, with 400 books from his personal collection, he opened the Glendale Public Library. Located in several different places in town over the next 20 years, the library finally got its own building in the town park in 1917. In this 1905 image, Postmaster Messinger relaxes in his post office, which was located in a corner of the Ryder Building.

GLENDALE
PUBLIC
LIBRARY
AT SCHOOL HOUSE
OPEN EVERY
SATURDAY
FROM 1 TO 4 P.M.

Vic Messinger, founder of the Glendale Public Library, came to Glendale in 1895 to become manager of the Ryder Lumber and Hardware Company. In 1897, as a public service, he opened a tiny public library in a building next to Ryder's, with 400 books of his own. In September 1898, Ryder purchased the building at the corner of Glendale and First (Fifty-eighth Drive) Avenues and moved his business. Messinger moved his library collection to an upstairs room over the new store. Around 1900, the upstairs was rented to the Odd Fellows Lodge and Messinger moved the books to the brick schoolhouse, two blocks north of the town park (Murphy Park). At that time, this sign was hung at Ryder's store to direct library patrons to the new location. In 1915, when the brick schoolhouse was torn down, the library moved again. In 1917, it finally ended up in a small building in the town park built around the park's flagpole.

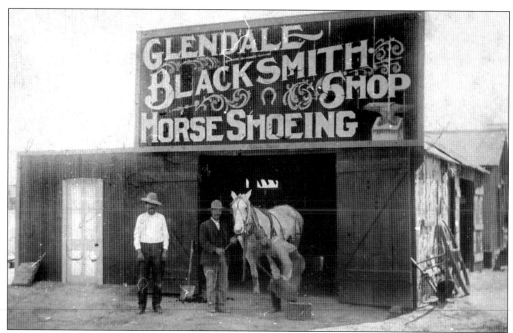

Anton Maldonado (right) is shoeing a horse in front of his blacksmith shop in Glendale, around 1904. On the other side of the shop, a wagon wheel and a one-horse plow hint at some of the other kinds of work a blacksmith was called upon to do. Maldonado's was one of the earliest blacksmith shops in Glendale, having been established in 1903.

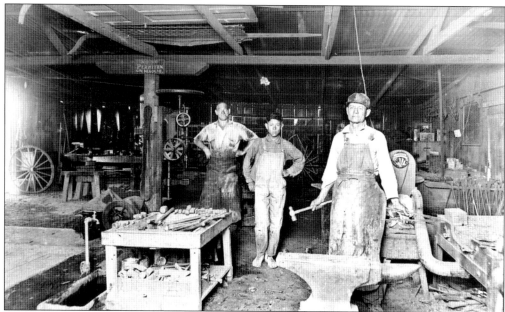

Anton Maldonado, hammer in hand, pauses in his blacksmith shop around 1918. Hispanics played a significant role in the development of Glendale. They worked on the Arizona Canal and on ranches and established businesses. Maldonado arrived in 1901 and set up his shop in 1903. Besides the usual work of shoeing horses, repairing broken wheels, and forging new equipment, Maldonado built buggies and caskets. He also worked on construction of the Sugar Beet Factory.

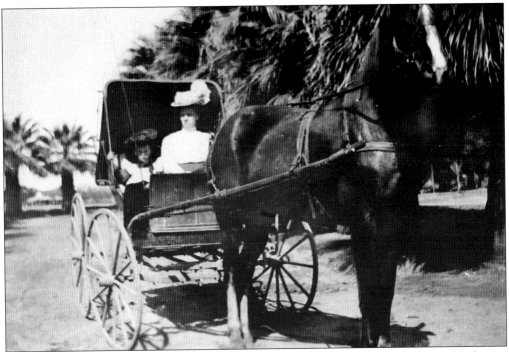

As wife of William Kuns, superintendent of Fowler Ranch, Elsie Kuns was privileged to have a horse-and-buggy at her disposal when she and her daughter Ruby wanted to go the two and a half miles to town to shop. Most folks in Glendale in 1908 got around by "shanks' mare" (one's own legs), but soon the automobile would change transportation forever.

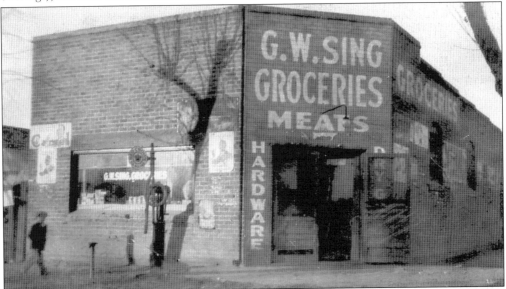

George W. Sing came to town in 1904, the first of several Chinese families to settle in Glendale. Among later arrivals were the Ong and Tang families. Sing's grocery store was located near Southwest Flour and Feed, thus a farmer could leave his wife's shopping list at the store, go to Southwest to unload his produce, and return to Sing's to pick up the grocery order. Sing's continued in business under his sons' management into the 1980s.

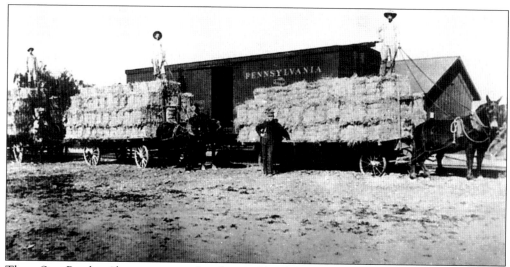

Three Sine Brothers' hay wagons are lined up at Glendale's Santa Fe depot ready to load hay into a rail car in 1905. The railroad came through Glendale in 1895 and played an important role in the area's agricultural success. The Sine brothers had several enterprises. There was farming, supervised by "Van" Sine; the hardware store and motor supply run by "Tuck" Sine; and Holmes Sine owned Glendale's first water system, a used furniture store, and a variety store.

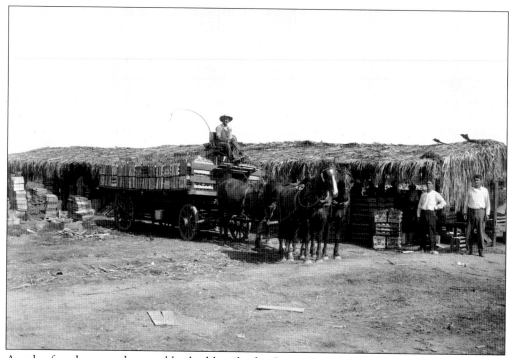

A palm frond–covered vegetable shed beside the Santa Fe railroad tracks was where farmers delivered their produce in the early years. The crates in the image are full of cantaloupes. After the Glendale Ice Company plant began operating in 1912, hundreds of icebox rail cars were shipped out of Glendale every year. By 1920, that had grown to thousands of cars annually, making Glendale the busiest produce-shipping center in Arizona.

Two

SUGAR CITY

Although known to many as Sugar City because of its sugar beet processing plant, Glendale never realized the promise suggested by that name. Not well suited to the cultivation of sugar beets, the Salt River Valley soil did not provide a reliable supply of high-quality sugar beets to the factory. In addition, there were problems with the quality of the water used for processing the beets. As a result, the Sugar Beet Factory produced sugar only on and off for only 10 years.

The failure of the sugar venture may have disappointed some in Glendale, but it hardly slowed the pace of growth and change. By 1910, when the federal census counted some 1,000 people in Glendale, there were two hotels, a bank, lumberyards, and a new post office. Soon the town could boast of having two grain-milling companies, Southwest Flour and Feed, and the Glendale Milling Company. The Sine brothers established a large hardware store, and there was a proliferation of grocery stores, meat markets, dry goods houses, and other mercantile businesses. Automobiles were still somewhat of a novelty in 1910, nevertheless, the town council established 10 miles per hour as the in-town speed limit.

The Crystal open-air picture show began its run in 1911, and the Rainbow Theater soon followed. The Phoenix Railway Company brought an interurban electric trolley to town (it lasted 14 years), the high-school district was formed, and the telephone exchange boasted over 100 subscribers. Russian immigrants arrived in 1911 and set about raising crops. The next year saw statehood for Arizona and Glendale's first newspaper, the *Glendale News*. A 28-ton-per-day ice plant serviced hundreds of railroad cars as the Valley farmers shipped produce all over the country, and the municipal-owned electric light and power business put a new spark into the town. In 1913, a modern new grammar school was under construction, and soon the 20-year-old brick grammar school was torn down. Glendale would soon be the 15th largest town in Arizona.

On the whole, Glendale prospered in the early years of the 20th century. Collapse of the sugar beet industry in 1916 did not affect the town for long. "Sugar City" became "Garden City" as emphasis shifted to melons, lettuce, cotton, hay, and other agricultural products.

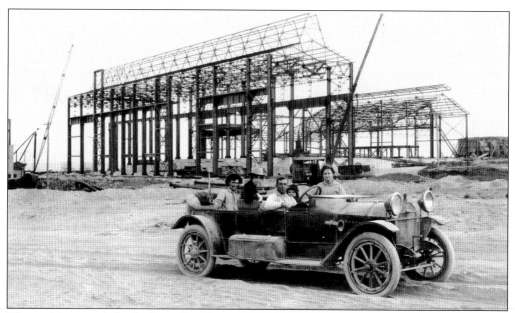

The steel framework for the Sugar Beet Factory rises from the desert floor a mile east of downtown Glendale in 1906. The bricks for the walls were made from locally dug clay by a portable kiln. The Thowson family, like many others in Glendale, periodically checked on the progress of construction by driving out to the site.

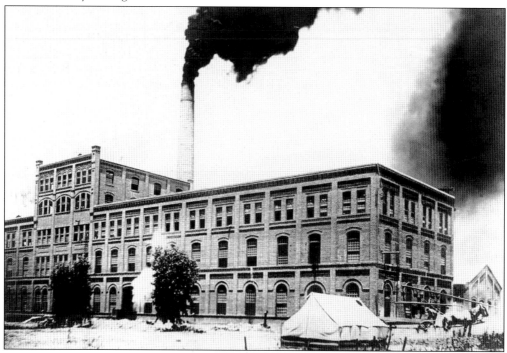

The south-facing front of the Sugar Beet Factory is pictured here in 1915. Smoke belches from the gigantic smokestack as sugar beets are processed into raw sugar near the end of its sugar-producing days. Empty and unused for years, the building still stands near Glendale and Fifty-second Avenues.

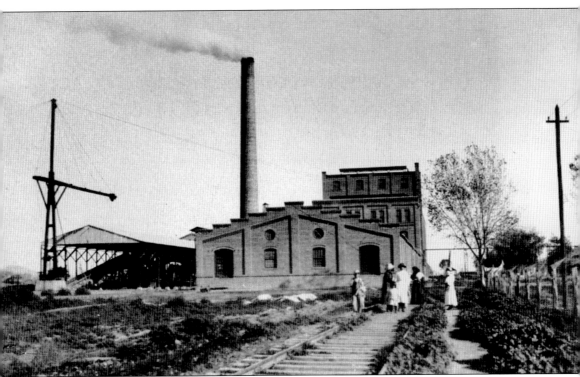

The towering smokestack of the Sugar Beet Factory was a Glendale landmark until it was taken down in 1951 after being damaged by lightning. In the years after sugar-beet processing was discontinued in 1916, several business uses for the building have been suggested or tried. Perhaps the most successful was by the Squirt soft drink company from 1938 to 1980. It leased part of the building for processing grapefruit into the concentrated base used by Squirt bottlers. The last tenant left in 1985 and the main structure has been unoccupied ever since. The five-story structure, one of Glendale's tallest buildings, is still a Glendale landmark.

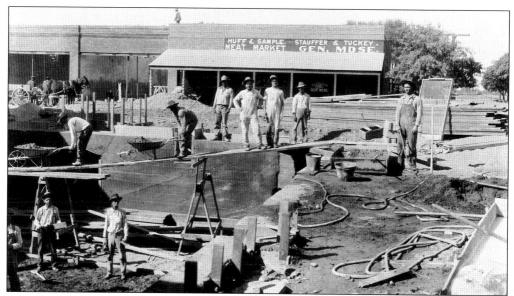

Workmen who are building the foundation and basement of the Gillett Building in 1909 pause to have their photograph taken. Located on the southeast corner of Washington Street (now Glendale Avenue) and south First Avenue (Fifty-eighth Drive) across from the town park, the building was completed by the end of the year. After the building was occupied, Charlie Gillett kept his pet wildcat in the basement, which was good protection from burglars.

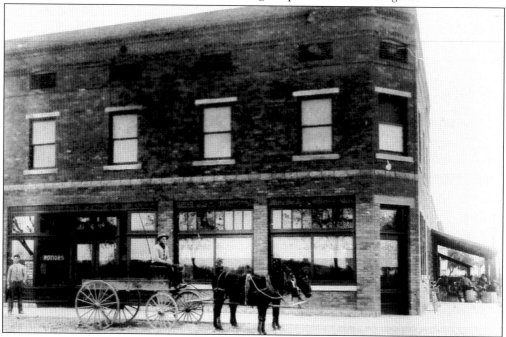

Roy Gillett is sitting on a wagon in front of the Gillett Building in 1910 after having delivered a load of goods to the grocery store of his brother Charles "Charlie" L. Gillett, who is standing (left) with his hand on his hip. The corner door (right) leads into the Glendale State Bank. In the early years, the upstairs was used for community meetings, school programs, and other celebrations. Later it was divided into office spaces.

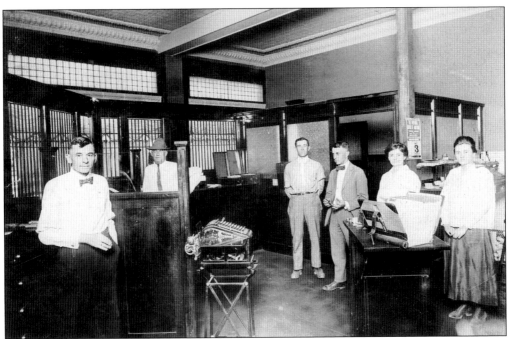

Inside Glendale State Bank, the staff is ready to serve the financial needs of Glendale, around 1915. When founded in 1909, the bank was located in the corner of the Gillett Building. In 1912, it was purchased by C. H. Tinker and moved to the east end of the street into a new building. In 1915, Tinker sold his interest in the bank and it returned to its former location. This was the first bank in Glendale. It did an extensive business in farm and livestock loans.

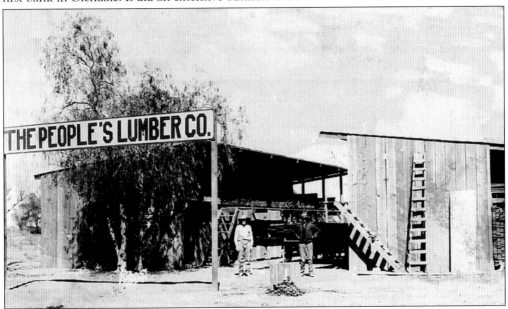

People's Lumber Company was owned by William Weigold, a carpenter and member of the Brethren congregation that arrived in Glendale in the mid-1890s. Weigold, with others, built several homes in Hadsell's Addition subdivision and business buildings in Glendale. One of his early houses was Hamilton House (later Manistee Ranch), built in 1897, just a mile north of downtown.

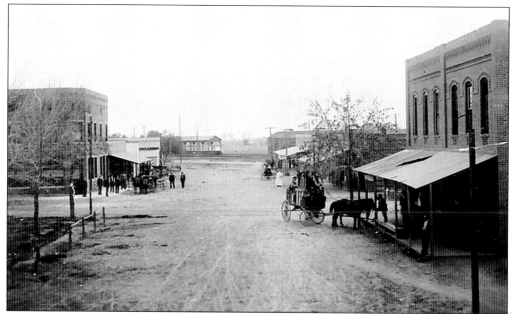

This is downtown Glendale, looking south along First Avenue (Fifty-eighth Drive), as it appeared in 1910 when horses had the right-of-way. On the left is the Gillett Building. To the right, customers congregate in front of the Ryder Building, which housed a hardware and furniture store along with a grocery store. The upstairs of Ryder's at this time was used as a lodge hall. Note the hitching posts (left) at the west edge of the town park.

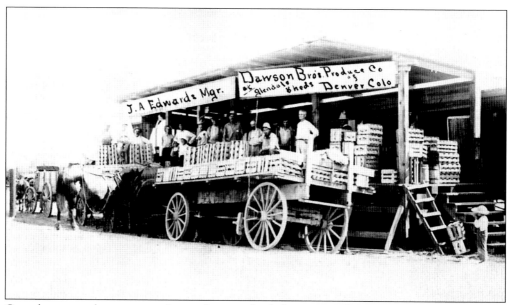

Cantaloupes on the way to market are being unloaded onto a produce-shed platform in the early 1910s. Typical of the day, when someone showed up with a camera, all work stopped and everyone "smiled for the birdie."

The Glendale city seal, with a sugar beet in the center, was adopted in 1910 when the sugar beet industry was considered to be Glendale's economic destiny. The seal was changed in 1951, long after Glendale farmers abandoned raising sugar beets. The new seal proclaimed Glendale to be the "Heart of Arizona's Agricultural Empire." In 1971, and again in 1979, the seal was changed. Both of these seals highlighted Glendale's promise for the future.

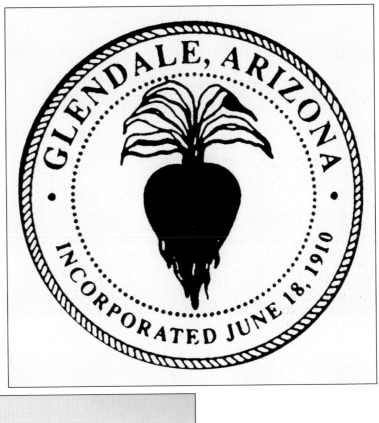

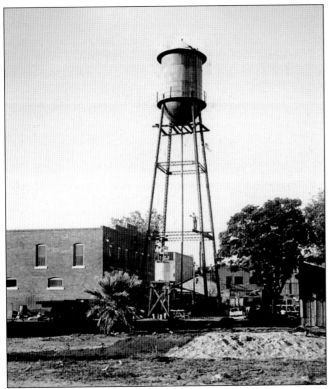

Floyd Holmes Sine may be considered the father of Glendale's municipal water system. He came to town in 1897 and began farming. In 1910, he bought Archie Bennett's two-year-old well and water system, the town's only public well and water system. After improving the system and adding a storage tank (left), he ran supply lines to serve downtown businesses. By the time he sold the water system to the town in 1915, he had some 160 customers.

This is the Rainbow Theater (second building from the right) as it appeared in the early 1910s. The first building on the right is the Bank of Commerce. The Rainbow opened in 1911 and was located west of the town park, where part of the city's Municipal Office Complex now stands. The theater was a metal structure with dirt for flooring and benches to sit on. The movie-projection equipment was a hand-cranked machine. A few years later, the dirt was covered with a proper floor, seats were installed, and in 1917 the metal building was replaced with a brick structure. In 1930, sound equipment was installed and Glendale entered the age of "talkies." The Rainbow continued to provide entertainment for Glendale into the mid-1930s. Then new owners modernized and renamed it the Glendale Theater. A few years later, it became the Plaza Theater. But newer and better-equipped theaters had come to town, and, not long after World War II, the Plaza closed.

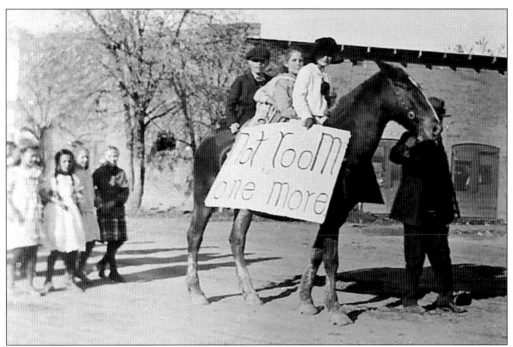

To the slogan "Not room for one more," students parade along Grand Avenue in 1912 (above) in support of a bond-issue proposal to fund construction of a new Glendale Grammar School. The placard near the front (below) depicts "the old lady in a shoe" overflowing with children. By 1912, the four-room brick Glendale Grammar School was extremely overcrowded. It was apparent that a larger school was needed, thus the demonstration. The bond issue passed in 1913. After the new school was built, the old school building was used for the upper grades through at least 1916. In 1919, it was demolished.

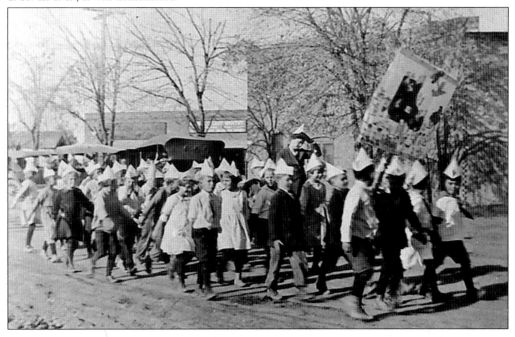

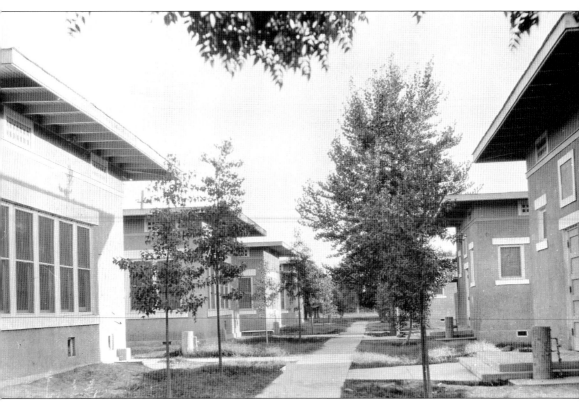

Glendale Grammar School, later called Landmark Middle School, was built on a novel, experimental plan called the "unit system." Starting with a few in 1913, eventually there were 36 separate classrooms, or units. Windows were placed on the west and north sides of each room to maximize natural lighting and provide good ventilation. Having individual units minimized the fire hazard, so fire drills were never required. Over the years, there was only one fire. It occurred in the 1950s, in room 36. At the time, it was being used as the band room. Each classroom was heated by several rows of steam pipes against the walls underneath the windows. Kids who sat in the row of desks next to the steam pipes had to be careful not to touch them in winter. An auditorium seating more than 1,000 was the focal point of the new campus. As the school-age population multiplied, other schools were built, and Glendale Grammar School was renamed Unit I. Today the auditorium survives as part of Landmark Middle School, and all but Room 35 of the "unit" classrooms are gone.

In the early days, before television and radio, recreational pursuits were limited largely by the imagination. There was, however, one playground in town, and it was located at the grammar school. Although sparsely outfitted with equipment, there was a favorite piece—a tall wooden slide. The heavily used slide required a lot of maintenance, so by the 1940s it was replaced by a metal slide. But that slide was often too hot to use.

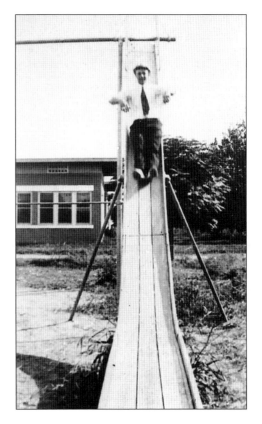

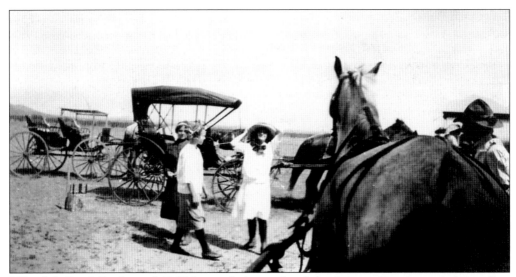

"Glendale Beach," at Lateral 18 (Fifty-ninth Avenue) and the Arizona Canal, was traditionally a place to party. In May 1914, the eighth-grade graduating class party at the "Beach" was attended by most of the class, including, from left to right, Ethel Messick, Agnes Whitney, Vida Roberts, and Bill Coffelt (at far right). Horse-drawn rigs, mules, and riding horses provided transportation for the five-mile trip north of town.

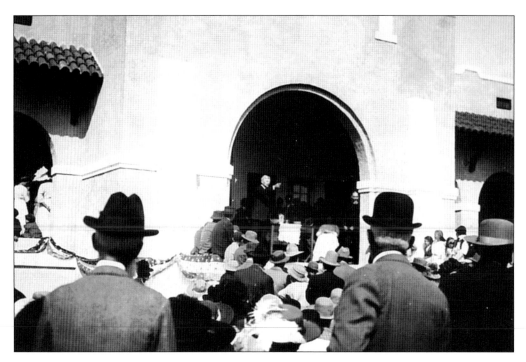

Vice-president-elect of the United States Thomas R. Marshall, above, delivered one of the dedication speeches for Glendale's new high school on February 12, 1913. In celebration, homes and businesses were decorated with bunting, there was a parade, and the crowd enjoyed a barbecue. The *Glendale News* described the event: "People [came] from every direction by auto, carriage, spring wagon, hay wagon, steam and trolley cars, horseback, and on foot. A parade two miles in length began the ceremonies, followed by a meal of barbecued beef and pork, along with many other good things to eat." Then came the speeches, and a baseball game that the high school team won by a score of 9-7 over the Glendale Stars. Below the crowd listens to the speeches.

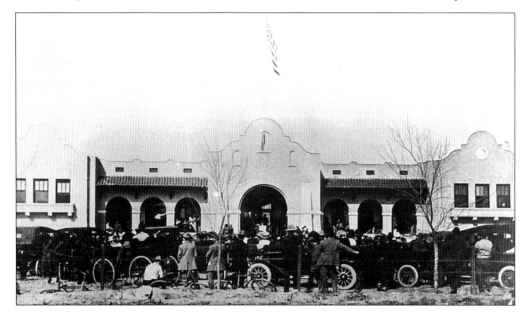

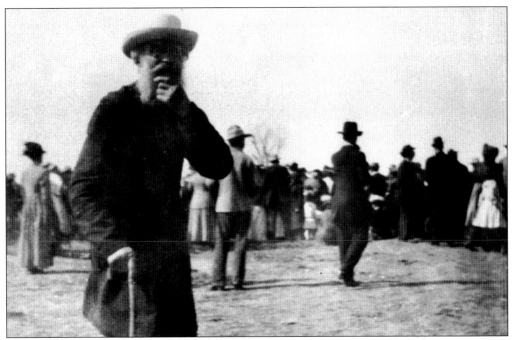

As the crowd begins to disperse, Brethren elder Peter Forney heads for home after eating free barbecue and listening to speeches at the dedication of the new high school on February 12, 1913. Perhaps half the population of Glendale and the surrounding countryside gathered for the celebration. The local newspaper reported, "The crowd . . . was beyond a doubt the largest and most impressive ever assembled for any purpose in this part of the Salt River Valley."

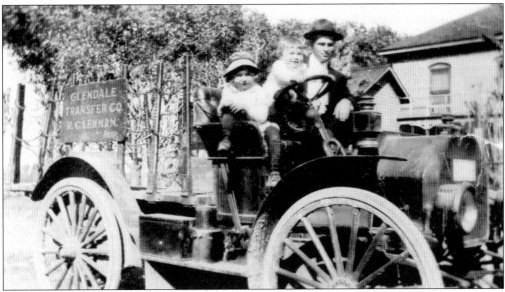

Ray C. Lehman, owner of Glendale Transfer Company, takes his two children for a spin in the company truck around 1914. Draymen, such as Ray, served a vital function in moving all sorts of goods and equipment in the days before hydraulic mechanization. Lehman's family home is in the background.

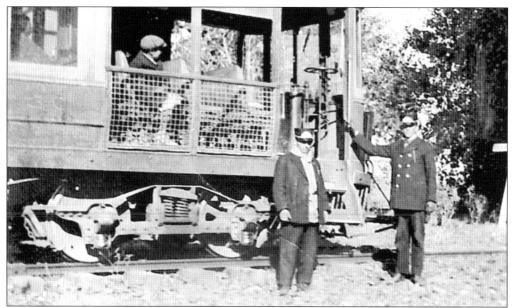

The Phoenix Railway Company inaugurated streetcar service between Phoenix and Glendale early in 1911 with five "big yellow" interurban cars. By May, there were 10 trips daily from each town. The price was 50¢ for a round trip. Advertised as a "pleasant outing," the streetcar ride was described as "a delightful one, passing through a beautiful country." In 1925, the line ceased operating because of financial problems. The tracks were removed in the 1940s.

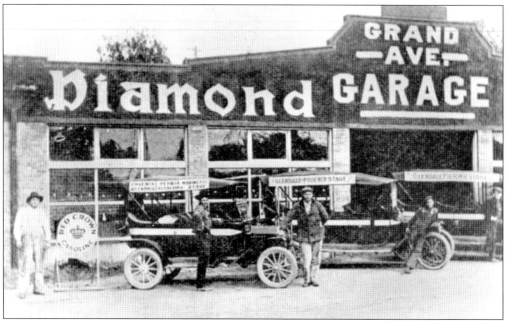

Rolling stock of the Glendale-to-Phoenix Belt Line Auto Stage is lined up in front of their headquarters in 1916. The stage company had an arrangement with the Phoenix electric-trolley line company to accept the motor stage's transfers. The Grand Avenue Garage was a busy place, but it was a good place to get automobiles serviced and repaired. It also sold Diamond tires, Goodrich tires and tubes, and Red Crown gasoline.

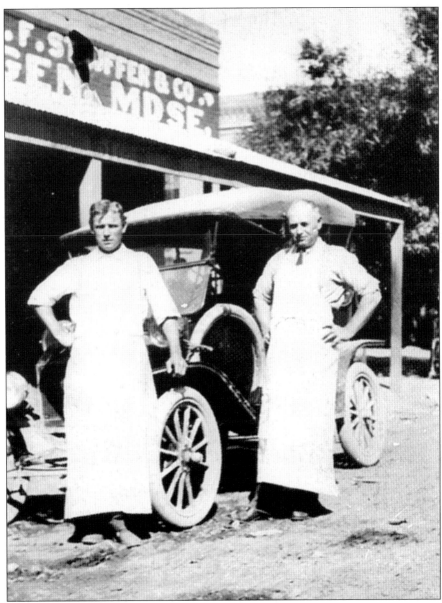

Roy Sample and his father-in-law, Ezra Huff, pause from meat-cutting to be photographed in 1909. Several meat markets served Glendale in the early days, and some were more primitive than others. For example, around 1900, Webb Wade would set up on Saturdays at an old tree stump just northwest of today's Fifty-ninth and Grand Avenues. There he would cut meat as long as he had customers. Other meat markets, such as Sample and More's Meat Market, set up in a shop or corner of a grocery store. Sample's market was next to Ray F. Stauffer's general merchandise store on the corner of Washington (Glendale Avenue) and First Avenue (Fifty-eighth Drive). Sample died during the influenza pandemic of 1918–1919, and his partner, Harry More, moved to California soon after. Sample's widow ran the business for a time but closed the market in 1925. Besides steer meat, they sold eggs, pork (especially sausages from their own recipe), bacon, lard, and other meat products. Their slaughter yard was located at Northern and Grand Avenues, around two miles from the downtown market.

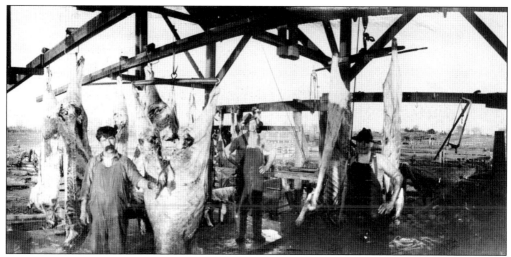

In 1917, Sample and More's slaughter yard was an open-air canopy located at Northern and Grand Avenues. There they kept meat on the hoof until it was needed. Once the meat was cut into manageable pieces, it was trucked downtown to the meat market where it was cooled in electrically refrigerated cases.

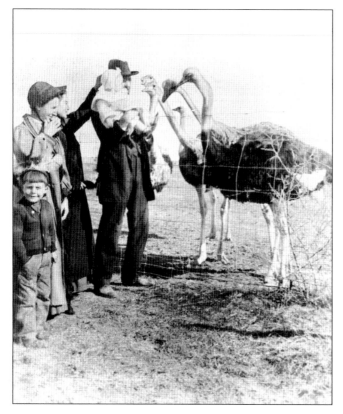

The whole family enjoys a visit to a Glendale ostrich farm around 1915. Ostrich plumes were a lucrative source of income for farmers. Adult birds would produce up to one and a half pounds of feathers per year for 20-some years. By the end of 1913, there were nearly 8,000 ostriches in Arizona, the most anywhere except in Africa. Several ostrich ranches were in the Glendale area, but the industry collapsed after World War I when ladies' fashion changed.

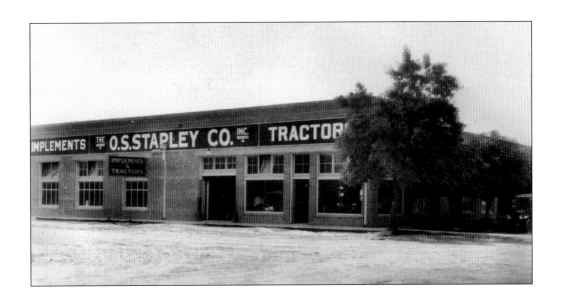

In the early 1910s, the O. S. Stapley Company (above) offered shoppers a hardware and farm-implement store second to none. There one could purchase a harrow or a seeder and a tractor to pull them (below). By the 1940s, the hardware department could offer a set of dishes, pots and pans, cutlery, or home-canning supplies. Glendale housewives were especially excited when Stapley's added a full line of "Fiesta" ware. They stocked all six of the original colors.

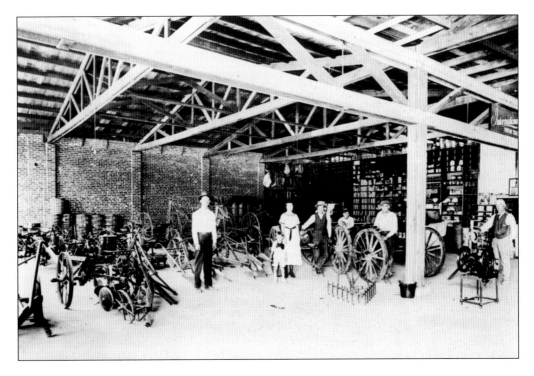

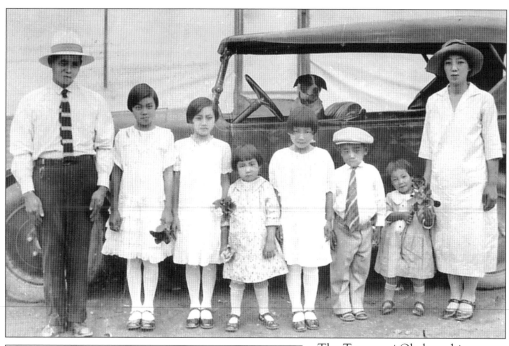

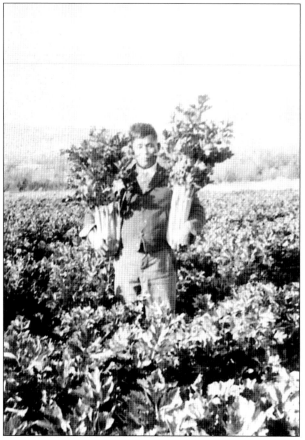

The Tsunenori Okabayashi family, including the pet dog Bob, poses for this photograph in 1928 (above). Okabayashi came to Glendale in 1907. Several other Japanese families came to Glendale from California in the early 1900s. They established truck farms that produced a wide variety of produce, especially lettuce, melons, and strawberries. Okabayashi was among the first Valley farmers to grow celery. Standing in his celery field (left), Tsunenori Okabayashi proudly holds a sample of his celery crop at harvest time.

In 1911, one of the largest parties of settlers ever brought to the Valley, 170 adults strong, arrived in Glendale by train from California. They were Russian farmers, carpenters, blacksmiths, laborers, and others who had been promised land to farm and freedom to practice their Molokan religion. Among them were Ivan and Fenya Treguboff. Although many of the Russians left a few years later when the sugar beet industry failed, some families, such as the Treguboffs, Tolmachoffs, Popoffs, and Uraines, remained in Glendale.

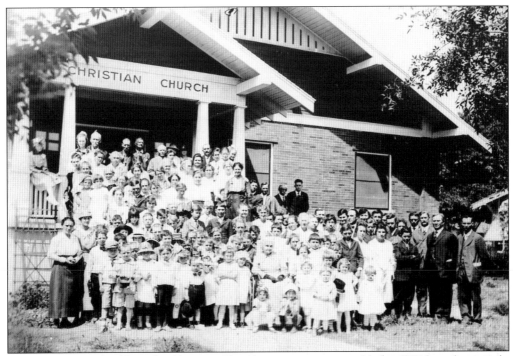

Proud of their new building, the Christian Church congregation assembled in 1917 for a photograph. Organized in 1914 with 29 members, the congregation at first met in the Glendale Woman's Club Building. The Church changed its name to the First Christian Church in later years. Today this former church building is a doll collector's haven called Sandy's Dream Dolls.

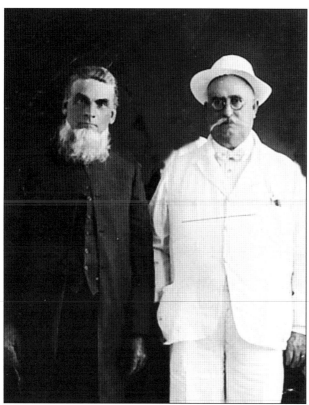

Brethren Church elder Charles E. Gillett poses with his friend, Democratic governor George W. P. Hunt in the mid-1910s. Governor Hunt was quite popular and always welcome in Glendale because he provided many jobs for the young men of the community. One Glendale mother voted a straight Democratic ticket at every election for nearly 40 years because Hunt gave her son a job in the 1920s.

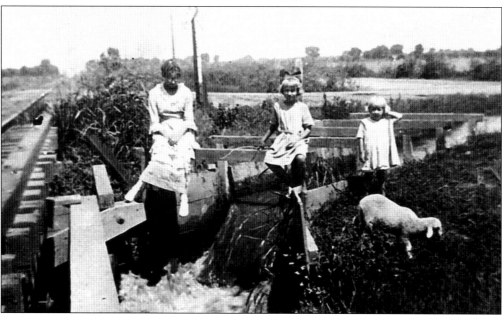

Jean Van Camp (left) looks wistfully at the surging irrigation waters flowing into a ditch on the Clarence T. Whitney farm at Grand and Northern Avenues in 1918. Van Camp's cousins, Lois and Joyce Whitney, and their pet sheep accompany her. This irrigation ditch is lined with wood. Some ditches were simply earthen, and others were lined with concrete.

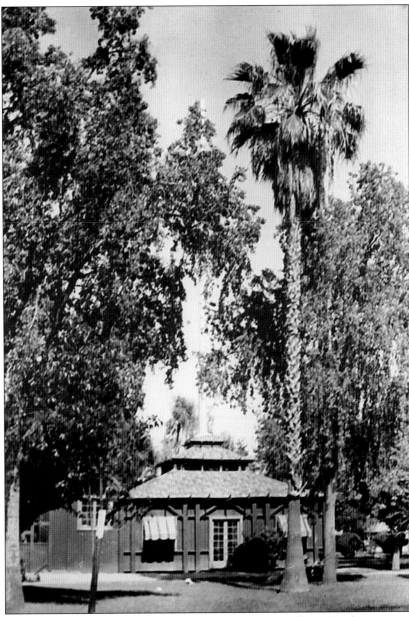

Glendale has had a library since 1897, when Vic Messenger made his 400-volume personal library available for loan to the townspeople. The library took up residence in several places in the early years including a small wooden building, the brick schoolhouse, and other locations. But in 1917, money was donated to build a library building. It was a wooden structure, erected in the town park (Murphy Park), encircling the town's record-setting, 110-foot, single-piece wooden flagpole. The "Flagpole Library," as some called it, served the needs of the community for 20 years, but by 1938 a much larger brick building was built to house the growing collection of books. The flagpole was not incorporated into the new structure but was moved and remained a prominent feature of the park until 1964 when it was taken down for safety reasons. The base was badly rotted, and it was feared that a windstorm might topple the old pole. It had held Old Glory aloft for 52 years. A 100-foot steel pole replaced it.

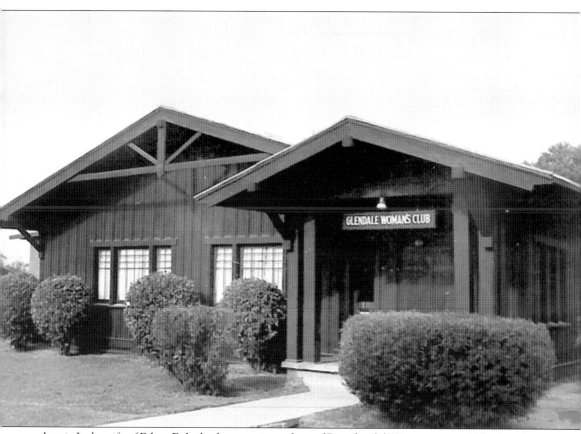

Lettie Jack, wife of Edgar E. Jack, the superintendent of Rancho del Higo, was one of the founding members and the first president (1902) of the "Self Culture Club." A few years later, the group renamed themselves the Glendale Woman's Club. In 1912, the club members raised the money to build this meetinghouse, which is still in use today. The building was a community asset that, over the years, was used for meetings, dances, wedding receptions, parties, luncheons, and more. In its 100-plus years, the woman's club has sponsored many projects from raising funds for the library, sponsoring flower shows and art festivals, helping to acquire and develop Thunderbird Park at the northern reaches of Glendale, and cleanup and beautification of Glendale.

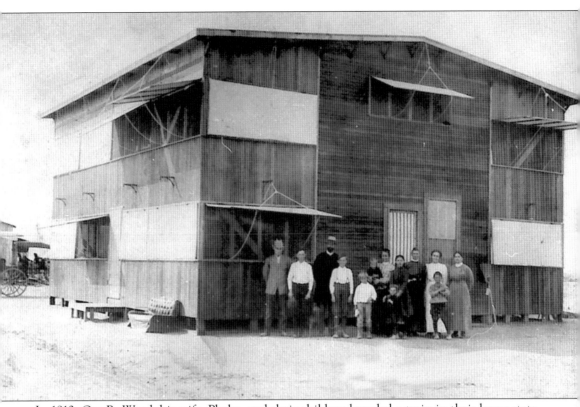

In 1912, Ora R. Weed, his wife, Phebe, and their children boarded a train in their home state of Kansas to travel with all their belongings to Arizona, where they had purchased 160 acres of land northwest of Glendale. Preacher, teacher, farmer, and manufacturer of brooms, Weed established a conservative Christian church and school that he named Old Paths. Weedville, as the community of some 40 families came to be called, sprouted a chapel, four classrooms, and this home for the Weeds. The Weed family supported themselves from donations, farming, operating a tiny country store, and making and selling brooms. When Ora Weed died in 1942, his vision of a privately owned Christian academy began to slip away. Little by little, the property was sold off. In 1952, the core buildings of Weedville were acquired to establish the Southwest Indian School at Thunderbird Road and Lateral 20 (Seventy-fifth Avenue). In the summer of 1912, the Weeds had their photograph taken in front of their home. Note the many "flaps" over screened openings that could be raised or lowered to adjust airflow. In front of the house, from left to right, are Harry, Jess, Ora R. Weed, Ezra, Enoch, baby James in mother Phebe's arms, Rachel (in front of) Huldah, "Sister" Cobb, Bessie Haroldson, and Mrs. Dudley and her son (in front of Bessie).

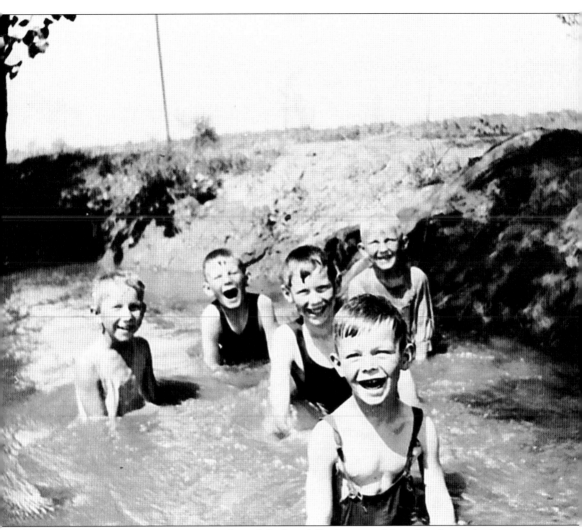

In the summertime, irrigation canals and ditches full of water, although inherently dangerous, were attractive swimming places for young and old. Two tow-headed Whitney boys, Forrest (left) and Marion "Mutt" (right), enjoy a splash in Lateral 19 near their home. With them in this image from the mid-1910s are three of their Michigan cousins.

Three

WAR AND PROSPERITY

World War I, for all its tragedies, brought prosperity to the Glendale area. The price of agricultural products soared. Cotton, especially, became a favorite crop; at one time it sold for $2 per pound. Perishable crops—melons, lettuce, and so forth—were also in high demand, and shipping them kept the Glendale Ice Company (later, Crystal Ice Company) busy icing the rail cars that carried the produce east and west. It was not just farmers who prospered. The whole area was seeing boom times and the creation of new businesses such as the Pacific Creamery and the Southwest Flour and Feed Company.

After the war, although slack times for some farmers, Glendale continued to move forward. By 1920, the population had swelled to 2,700, almost three times what it was 10 years earlier. More people meant more housing, which meant that suppliers of building materials and workmen to assemble them were kept busy. In downtown Glendale, many of the ever-popular bungalow-style homes were built in the Catlin Court residential area. Many downtown streets were paved, including Grand Avenue. Streets were renamed and numbered to post office specifications for free mail delivery in town. The high school was regularly graduating some two dozen students, new churches were gaining a foothold, and lodges and civic organizations were flourishing. The new U. S. Government Poultry Experimental Farm was set up south of town, and the whole town celebrated "Chicken Day" in honor of Glendale's poultry businesses.

Baseball was the popular entertainment, especially when winning teams were fielded. Glendale's second newspaper, the *Saturday Shopper*, was first published. And in 1928, to the delight of the whole town, Glendale's first swimming pool, the Silver Pool, opened to the public. The focus of business was, as it always had been, the streets close to the town park (now Murphy Park). Among other businesses around the park were a hardware store, two dry-goods stores, five markets, a movie theater, and a real estate company.

In the 1930s, a new library was built in the park, and nearby a second grammar school was started. By mid-decade, after the repeal of Prohibition, alcohol-free Glendale permitted the sale of alcoholic beverages. The annual Mexican Independence Day fiesta continued to be a popular fall event, and dial telephones arrived in 1937. By 1940, Glendale's population had grown to 4,869.

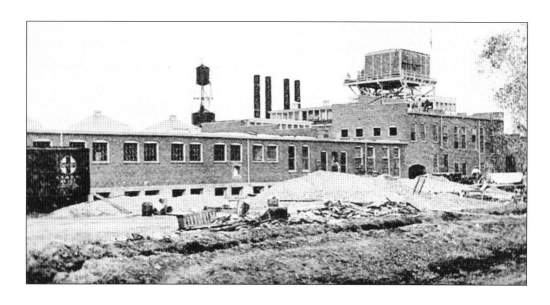

Construction of the Pacific Creamery Company's milk-condensing plant, half a mile southeast of town, nears completion in 1916 (above). The plant was built in response to soaring milk production during World War I, and it cost more than $400,000 to complete. Its main product was "Armour" brand canned milk. Falling prices for milk after the war brought a decline in the dairy industry, and as a result, the company closed its milk-processing operations in 1920. The plant was reopened as Webster's Associated Dairy Products Company in 1933 under the ownership of Dudley B. Webster. It operated under two other owners until 1971, when it was closed for good. A look inside the Pacific Creamery Company plant in 1917 (below) reveals a complex array of equipment.

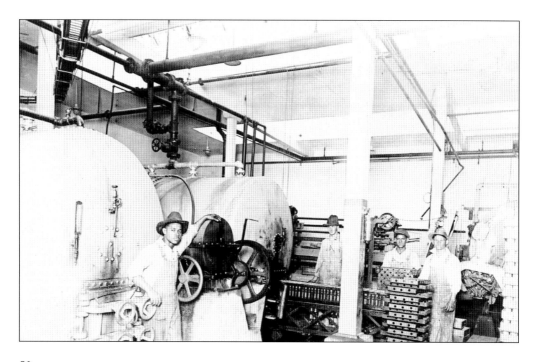

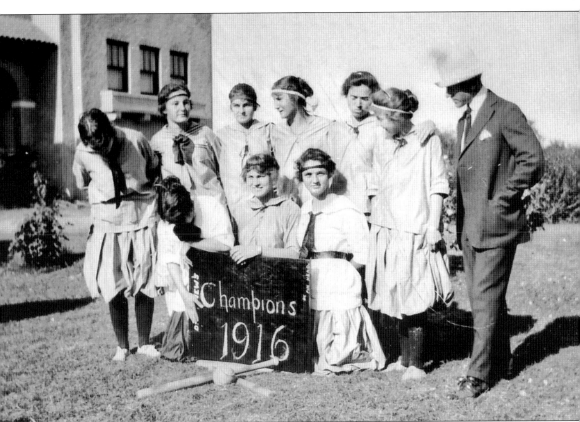

By winning five of six stipulated games in 1916, the high-school boys' baseball team, the Sugar Kings, were lionized as champions. The girls' softball team, the Sugar Queens, also had a winning season. They won two of the three games (all against the Indian School team) they played, so they proclaimed themselves champions. The 1916 team consisted of Julia Campbell, pitcher; Vida Roberts, catcher; Frances Green, first base; Gail Campbell, second base; W. Long, shortstop; Ruth Forney, third base; Hazel Spillman, outfield; W. Champie, outfield; and Marguerette Brooks, outfield.

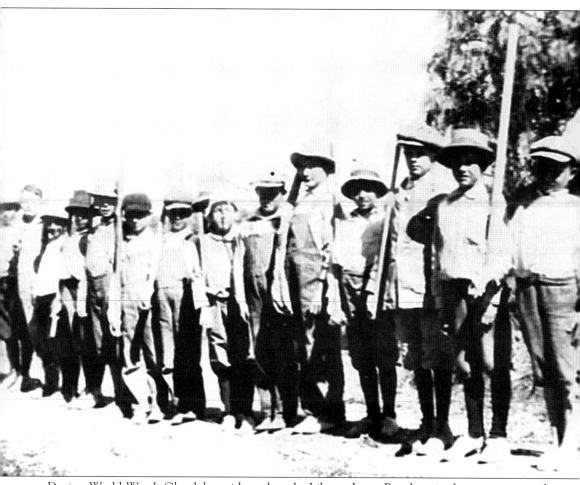

During World War I, Glendale residents bought Liberty Loan Bonds, raised extra crops, and supported the war effort in other ways. Children, as well as adults, found ways to show their patriotism during the war. Youngsters dressed in doughboy attire would routinely defeat the "Hun" on their homemade battlefields. An especially desirable accoutrement, if a boy had one, was a broad-brimmed, military-appearing hat. Toy airplanes were also popular for playing at war. Even though there was no threat of attack in Arizona, these neighborhood boys were prepared with sticks and pretend rifles to defend the home front in 1917.

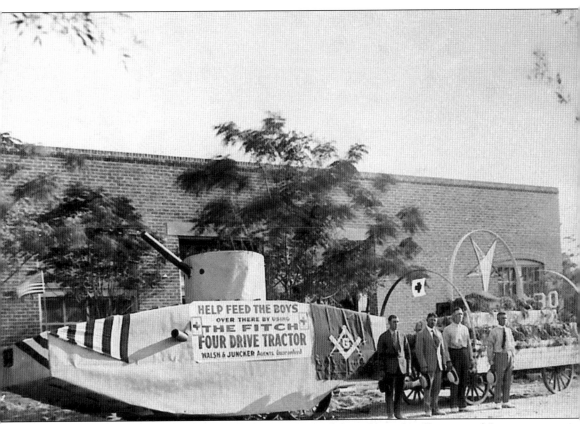

In support of the war effort in 1917, Glendale residents observed meatless days, raised "victory gardens," bought War Savings Stamps, and joined in parades to stimulate war awareness on the home front. This float was built on a Fitch four-wheel drive tractor, which is pulling a hay wagon. The Masons, Eastern Star, and Fitch agents Fred Walsh and Charles Juncker sponsored the float. Juncker, a local blacksmith, is second from right, and Bill Coffelt, his apprentice, is on the right. The other two men are unidentified. A short time after this parade to "Help Feed the Boys Over There," Coffelt joined the Marines and went to Washington state for basic training, and Juncker went to work in a shipyard in San Francisco for several months.

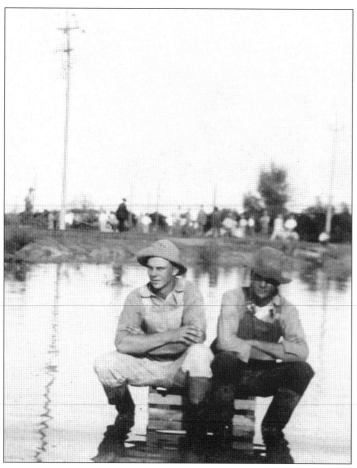

The most severe wind and rainstorm in Glendale for years, according to the *Glendale News*, occurred the evening of July 26, 1917. In the flooded aftermath, everyone pitched in to sandbag merchants' shops and repair a washout of the railroad grade. Pictured at left, two local boys, Charlie Pitts (left) and Walter Grassie, worked as hard as anyone, but they took time out to have their picture taken while sitting in the middle of flooded Grand Avenue. Behind them is the railroad grade that was breached by the floodwaters. The image below is of the first engine across the repaired washout. The repair is visible below the rear wheel of the engine. Several months after this flood, Grassie died while serving in World War I.

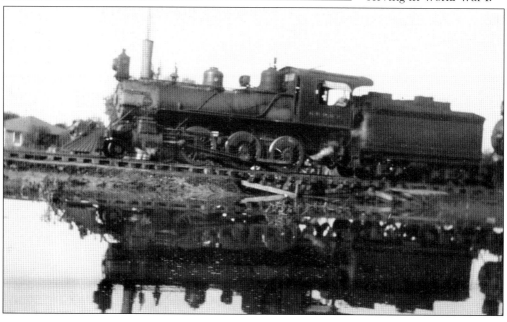

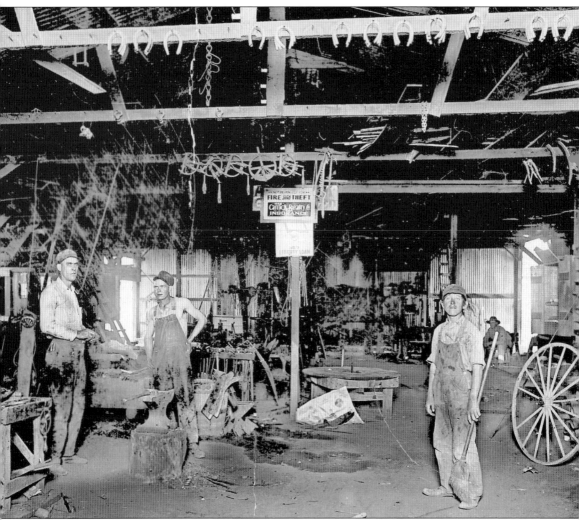

As far as the farmers of Glendale were concerned, the most important businesses in town were the blacksmith shops. They made it possible to keep equipment in good repair and workhorses shod, which were critical needs at the times of seeding, harvesting, and marketing. Founded in 1911, Charles Juncker's Blacksmith and Machine Shop was the most modern it could be. In 1919, he advertised that all of his saws, drills, emery sanders, planers, and forges were operated by electric-motor attachments. Juncker, of course, did the usual sort of work common to blacksmiths, but he also repaired and rebuilt automobiles and sold new tractors. The shop was especially known for its custom building of such farm equipment as hay derricks, rakes, wagons, and other farm machinery. The shop workers are, from left to right, Charles Juncker, Bill Coffelt, and an unidentified apprentice.

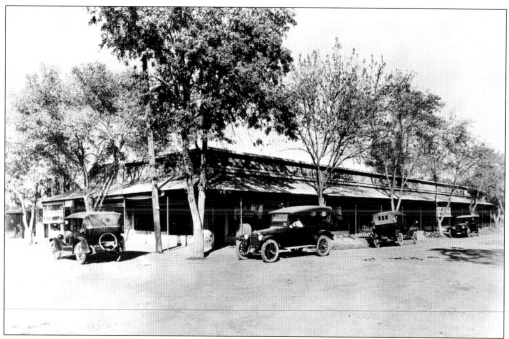

For a few years, beginning in January 1918, the Tharpe Building (above) on the corner of Washington Street (Glendale Avenue) and Second Avenue (Fifty-eighth Avenue) housed the U.S. post office in the corner of the building. After World War I, down the street on the far right, soldiers used one room to meet as they attempted to organize an American Legion post. Next door to the post office on the north (above, left) was the Post Office Meat Market (below), owned by Bessie and Ray Stockham. The sign on the wall of the meat market proclaims, "Pay Cash and Pay Less." North of the market was the Pantatorium, a dry-cleaning establishment.

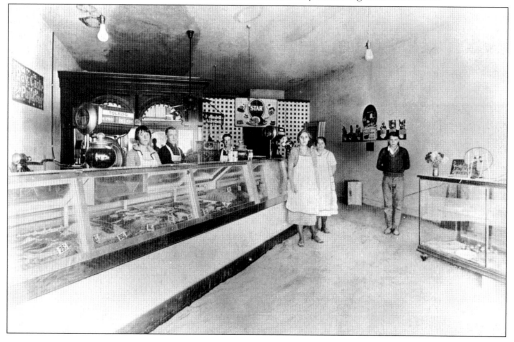

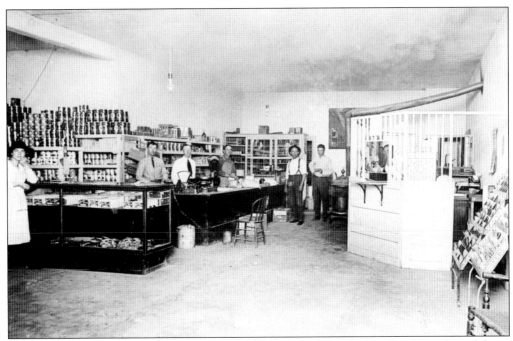

Kitty-corner from the town park in 1919 was Beaty's Market, which carried "staple and fancy groceries; fresh fruits and vegetables brought in daily; and butter and eggs." The bookkeeper's cubicle on the right (above) is where items were purchased or added to the buyer's account. Besides the usual market goods, James R. Beaty carried home-canned products bartered from customers. Note jars of home-canned food on the shelves at the back of the store (below). Beaty also took in trade, as was common practice in those days, eggs, butter, fruits, and vegetables. The rooms above the market were used as a hotel for several years.

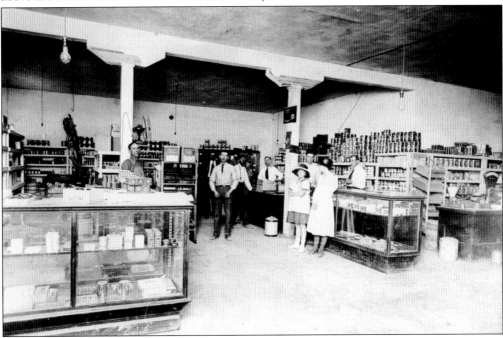

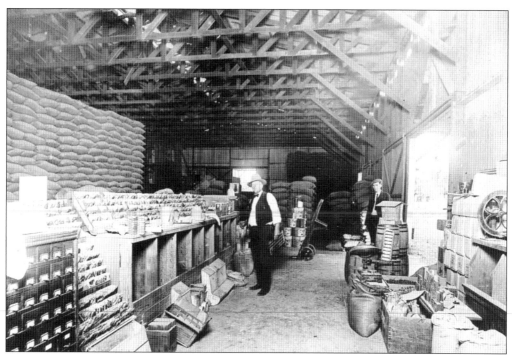

Harry Bonsall Sr. checks operations in his warehouse at Southwest Flour and Feed Company around 1920 (above). Southwest was one of Glendale's leading businesses for decades, and Bonsall was a respected civic leader who was referred to by some as "Mr. Glendale." Shortly after the plant opened in 1919, the *Glendale News* described it as "a modern and thoroughly complete plant for grinding and rolling feed." And the farmer was assured that large tonnages of feed could be handled because the plant was "motor driven." In addition to Red Star brand flour, Arizona Rose brand flour, and various feeds, Southwest stocked rock and block salt, coal, and wood. The warehouse (below) offered 10,000 square feet of space that could store up to 15 million pounds of grain.

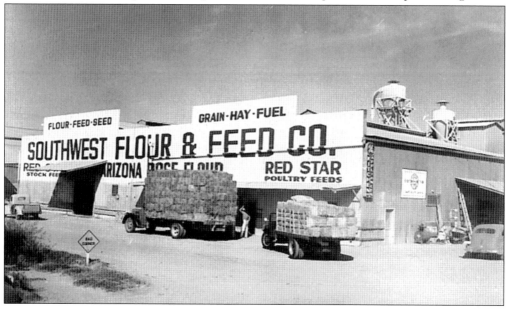

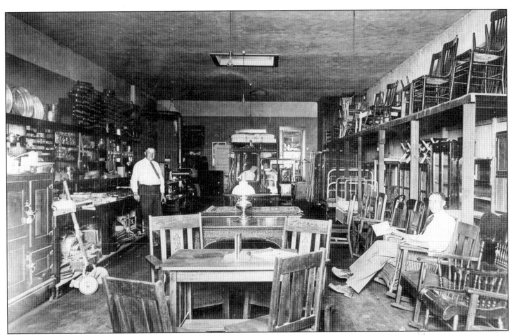

Coming to Glendale in 1915, Charles M. Harper (above, left) established the Oasis News Company, which he soon expanded into Harper's Drug Store. In 1918, he sold his drug store to Carroll M. Wood who changed its name to Wood's Pharmacy (below). A few months later, in 1919, Harper bought Lower Furniture Store, located next to Grant McArthur's secondhand store, from Delbert E. Lower and renamed it Harper's Furniture Store. His stock included "moderate priced chairs, tables, rugs, dishes, stoves, beds, trunks, and many other items." One of those "other items" was a lawn mower (above, left). Harper served as mayor of Glendale in 1934 and 1935. Harper's partner, Holmes Sine (above, right), tries out a rocking chair.

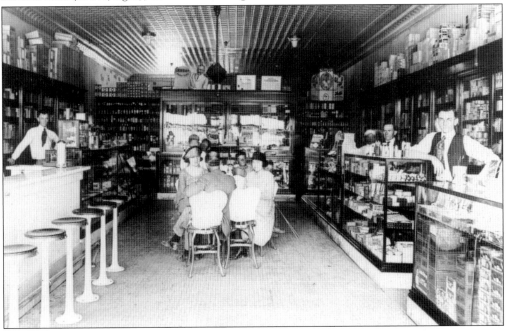

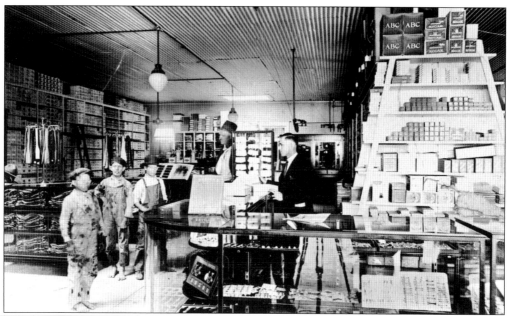

Three young men (two barefoot) look over the wares offered by Stauffer's general merchandise store in the early 1920s. Ray Stauffer grew up in Glendale and was one of the early businessmen in Glendale. He started with a small grocery and general merchandise store, but he always included a line of men's furnishings and shoes as part of his stock. In 1917, he separated the men's clothing department from the grocery and provisions department and added ladies and children's shoes and stockings.

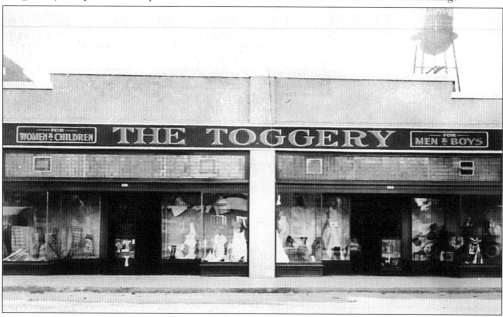

In 1920, after the Toggery moved into the building previously occupied by the Crystal Theater, something new appeared around the town square—a showcase storefront. Manager Bob Reynolds kept the window displays well outfitted with examples of the quality clothing lines he carried for women and children and for men and boys. Seen faintly in back of the building (right) is a storage tank for the municipal water system.

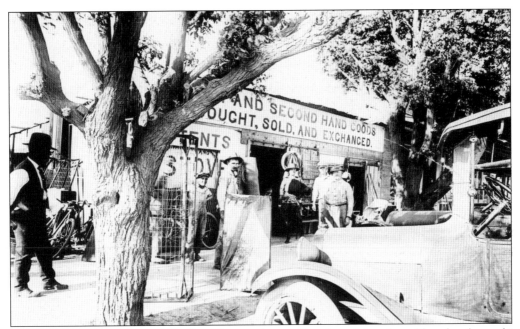

Grant McArthur's corner in 1920 offered "new and second hand goods bought, sold, and exchanged." McArthur died in 1920, after which his wife, Annie, ran the business for a short time before she sold out and moved away. McArthur's was right downtown, located on the corner where Washington (Glendale) Avenue, Lateral 18 (Fifty-ninth Avenue), and Grand Avenue converge. Today part of the Municipal Office Complex parking structure sits atop the corner.

Irving "Irv" Thowson (center), standing behind the meat showcase of the Glendale Pay'n Takit (later Safeway), is ready to sell customers a slab of bacon from the six-deep pile on the showcase. When Thowson's wife, Alma, helped at the market she brought her baby son, Gordon, with her. He was placed in a basket and put on a big shelf in the showcase, hopefully to sleep. Alma marked this 1921 image with an "X" (right of center) to indicate which was the baby's case.

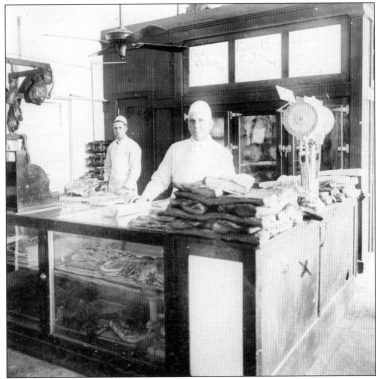

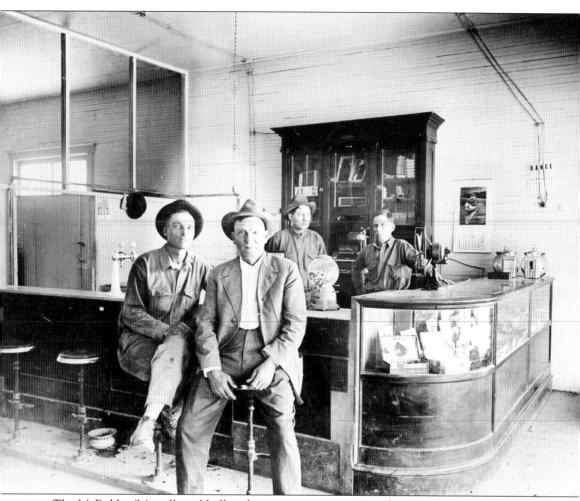

The McFadden/Morrell pool hall and cigar store was just one of several that came and went in the 1920s. Pool halls, or billiard parlors, were a favorite place of entertainment for some in the early days of Glendale. The proprietors of one pool hall, down the street from the town park, were James Ross "J. R." McFadden and his brother-in-law, William "Bill" Morrell. In front was their cigar store and in a back room were the pool tables. The business partnership did not last long. J. R. was elected Maricopa County sheriff and in 1931 had the dubious honor of bringing the infamous "trunk murderess," Winnie Ruth Judd, back to Phoenix from Los Angeles. When he lost his reelection bid in 1932, he blamed it on his participation in the Judd case. After McFadden and Morrell left the pool-hall business, the pool hall became a barbershop; in front was the barber and in back was a bathhouse. Thus a man could get a shave, a haircut, and his weekly bath all in one location.

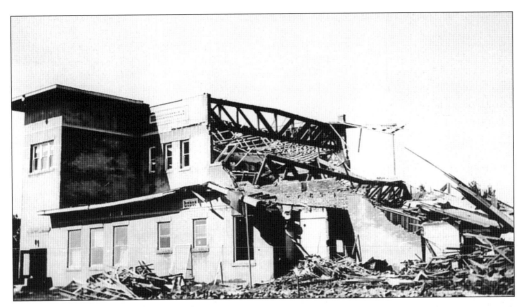

On August 19, 1921, Glendale was visited by the most destructive storm since its founding. The grammar-school auditorium (above and below) was particularly damaged. Its roof was almost completely blown off, and the north end of the building was demolished. The storm was described as a "miniature tornado." It whipped Manistee Ranch, destroying a silo and drenching the home's interior. It took out several houses in Catlin Court and narrowly missed the Methodist Church. The tornado ripped roofs off of Anderson's Garage, Juncker's Blacksmith Shop, Halstead Lumber Company, the warehouse of Glendale Ice Company, and other buildings. The water-pumping plant was put out of service, as was the electric company. Telephone service was also disrupted for hours, and in the downtown area many signs and awnings were cast loose.

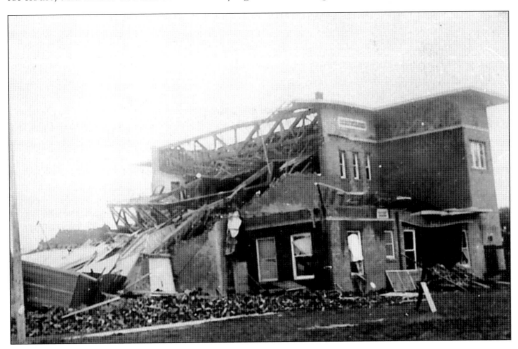

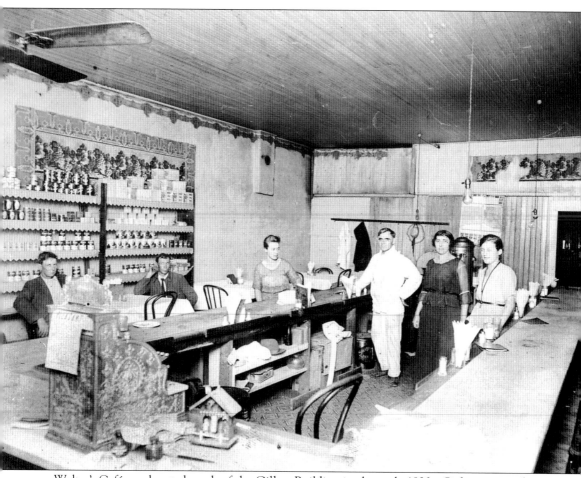

Walter's Café was located south of the Gillett Building in the early 1920s. Cafes came and went often, either because business was poor or the owner got tired of the daily routine. Over the years, there were several different cafes in this same location. Notice that on the counter by the cash register is a small "house." It is an up-to-date weather predictor. If the white figure emerged from the house, it would be good weather, and if the black figure (often a witch) emerged, rain and bad weather could be expected. Devices such as this were popular well into the 1940s. They worked pretty well in Glendale, where seldom there was bad weather.

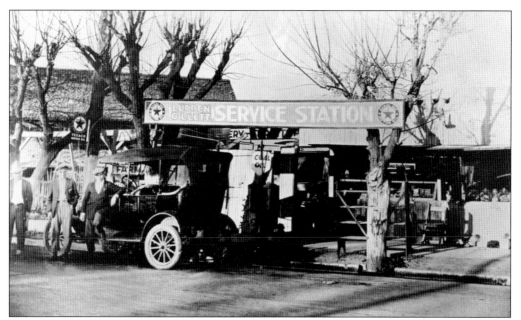

Texaco products were available in 1923 at the service station of Homer C. Ludden and Charlie E. Gillett. Gillett's daughter Flora (Gillett) Statler was one of the attendants who pumped gas. Later she opened a real estate office in town with Ludden. Besides developing the Floralcroft Addition to Glendale, Statler and Ludden secured the agreements to purchase the Luke Field properties in 1940 to start development of the town of Surprise, Arizona.

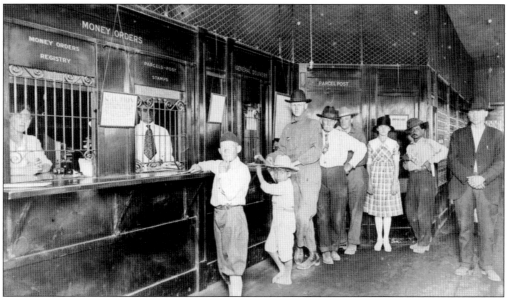

Here is the interior of the new U.S. post office on south Second Avenue (Fifty-eighth Avenue) in the early 1920s. Even the littlest customer wore a hat in those days. The barefoot boy at the front of the line is Frank Thuma. Moving post-office locations seems to correspond to national elections. A change in the political party controlling the government resulted in appointment of a new postmaster, and often the post office would be relocated. During Franklin Roosevelt's years in office, there was only one postmaster in Glendale and one location for the post office.

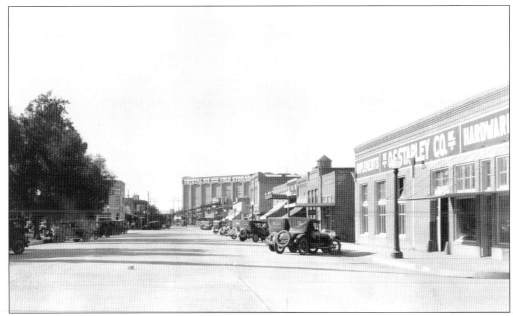

Downtown Glendale in the 1920s had streets lined with the automobiles of shoppers. This image is looking south down First Avenue (Fifty-eighth Drive) toward the Crystal Ice Company warehouse. On the left is the town park (Murphy Park). South of the park is Newman's Department Store and Sine Brothers Hardware. On the right are O. S. Stapley's, a vacant lot, the police department and jail, and city hall.

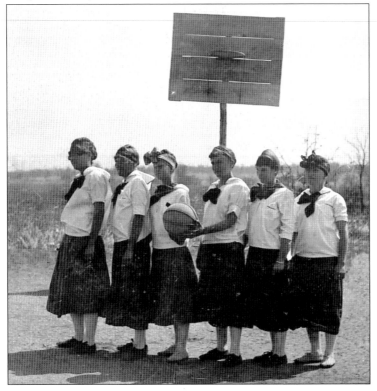

The boys were not the only athletes at Glendale Union High School in the early days. Although they did not participate in rough-and-tumble sports such as football, the high school girls did have a basketball team that competed with other teams. Perhaps practicing outdoors on a graveled court with a dilapidated basketball hoop and backboard made the girls tough. In the 1920–1921 season, the girls' team won every game they played and claimed the state championship.

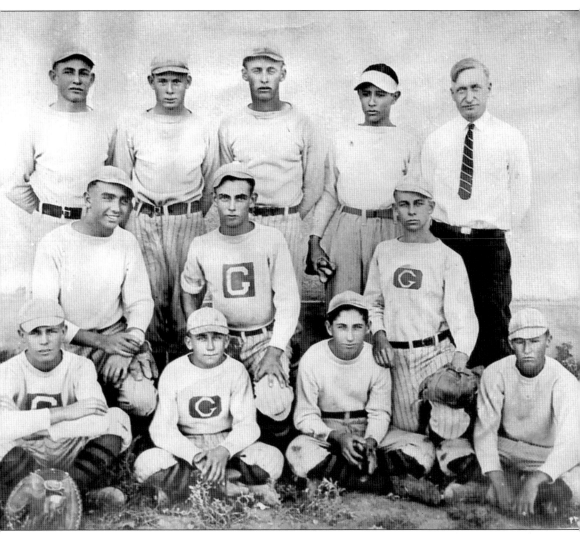

Baseball was a favorite pastime in the 1920s and 1930s. In 1923, and again in 1926, Glendale Union High School had a team that won the Arizona state baseball championship. Ed Tussey, who coached both teams, remembered that "merchants would close their stores on Friday afternoons for the games" and 4,000 or 5,000 people, more than the whole population of Glendale, came to watch the team play. The 1923 championship team (above) consisted of, from left to right, (first row) Cliff Pullins, Merle "Pee Wee" Heatwole, Frank Sancet, and Oyer Dugger; (second row) Bill Betts, Bert Pullins, and Stan Novis; (third row) Willis Moore, Elton Yancy, Bill Steenburger, Alex Maldonado, and coach Ed Tussey. Pee Wee, who was less than five feet tall, was fond of recalling how he drove some teammates in his father's car to the championship game. Since he could not reach the pedals, he steered and shouted instructions for braking and accelerating to another boy who operated the pedals. In addition to high school baseball teams, Glendale also fielded a semiprofessional team, the Glendale Grays (sometimes spelled Greys), from around 1916 until 1958.

Joseph Ysidor Otondo (left), a Basque sheep rancher, had winter pasture for his flock in Glendale and summer pasture in the high country in northern Arizona. The Otondo family visits dad (below) and the herd on the move near Glendale. Several Basque families, among them the Ajas, Ipharrs, and Hidalgos, made Glendale their home. During the school year the families stayed in Glendale, but during summer vacations they lived in the sheep camps up north. Other ethnic groups that formed important segments of the Glendale community were the Japanese, Chinese, Hispanics, Russians, East Indians, and those of Middle Eastern descent.

On their parents' farm west of Glendale, three Treguboff boys tweak the tail feathers of a turkey that soon took its revenge on the boys. But farm animals were not pets or toys, so the turkey eventually ended up in an oven.

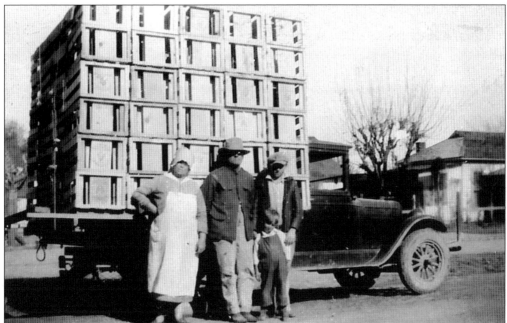

Not every farmer had crops large enough to be shipped to distant markets in railroad car lots. The Darby family, for example, trucked produce from their small farm the few miles to Phoenix to sell at the farmer's market. This day, in 1927, the truck is loaded with crates of lettuce.

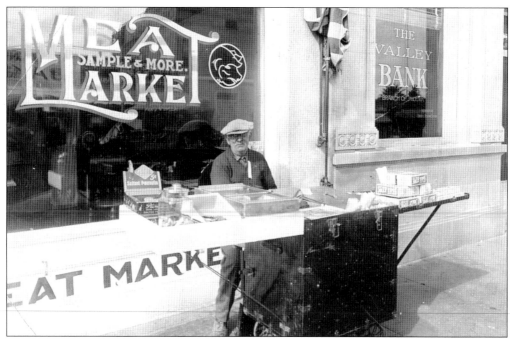

Sidewalk merchant Solomon O. Furrey for a few years was a fixture on First Avenue (Fifty-eighth Drive), just south of Glendale Avenue, in front of Sample and More's meat market and next to the Valley (National) Bank. Listed in the city directory as operating a confectionary stand, Furrey, pictured here in 1924, offered candies, peanuts, newspapers, and other sundries to passers-by.

Members of the German Baptist Brethren (Church of the Brethren) visit with other members of the congregation following the morning worship services in this 1920s image. They were plain dressers by tradition. Elder Ola Gillett (hatless by the window) is dressed in a traditional collarless plain suit and not wearing a tie. Facing Ola, with her back to the viewer, is his wife, Minnie, wearing the traditional woman's prayer-cap covering.

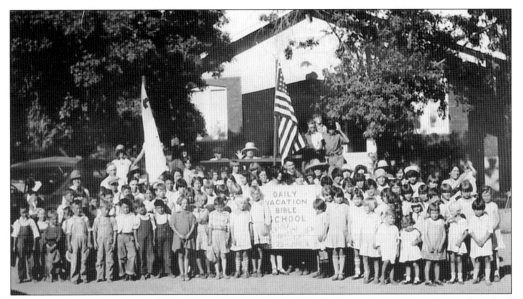

Children enrolled in the Daily Vacation Bible School of the Calvary Baptist Church stand washed and scrubbed for their photograph in front of their church in June 1927. Churches have always been an important part of Glendale's social and cultural life. In the 1930s, there were more than a dozen denominations in town.

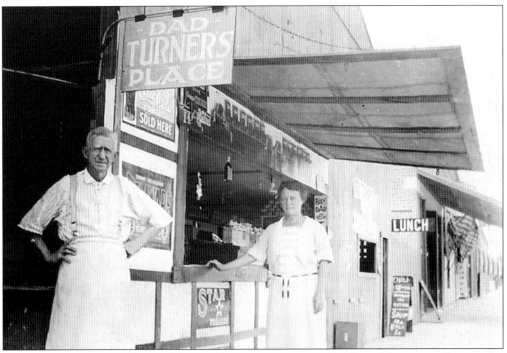

Jeff A. "Dad" Turner (left) and his wife came to town in 1919 from Missouri and opened a confectionery stand on the west side of the town park. In 1920, he took over the City Café down the street. In 1926, Turner was appointed postmaster at Wittman, 25 miles northwest of Glendale. He moved there and opened a café and service station. From earliest times in Glendale, there was always a café or restaurant on the square, even to the present day.

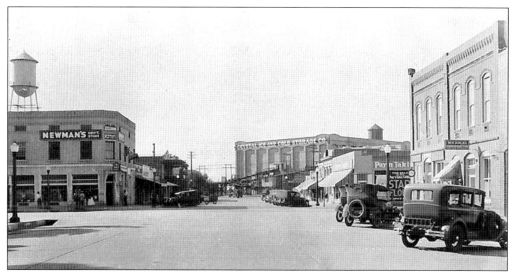

This is downtown Glendale, looking south along First Avenue (Fifty-eighth Drive), as it looked in the late 1920s. On the left is a storage tank of the municipal water system. Newman's Department Store occupies the Gillett Building. The large building at the end of the street, which parallels Grand Avenue and the Santa Fe railroad tracks, is the Crystal Ice and Cold Storage Company plant.

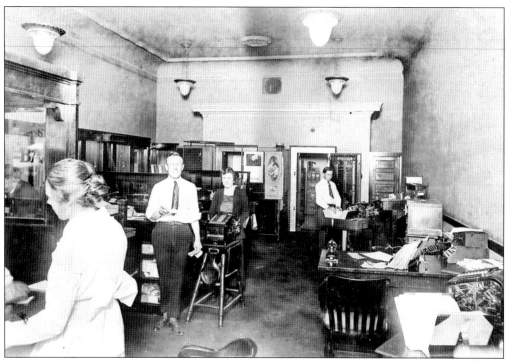

The Valley National Bank in the mid- to late-1920s was a busy place, but hard times were ahead. The nationwide banking crisis of the early 1930s ruined many banks in Arizona and the nation. Valley National, however, survived and became a powerful Arizona bank. It continued until 1993, when Bank One acquired it.

An Arizona sleeping porch was little more than a screened room with canvas flaps of one sort or another to regulate the airflow through the openings. In the 1920s, the sleeping porch of Esther and Henry T. Burton had moveable flaps on two sides of the room. By propping open the flaps in hot weather, one would have a cooler place to sleep than in a bedroom. Besides, many small homes had only one bedroom and a sleeping porch. In that case, the whole family would sleep on the porch, and the bedroom would be saved for guests or when someone was sick. Evaporative coolers and air conditioning eliminated the need for sleeping porches.

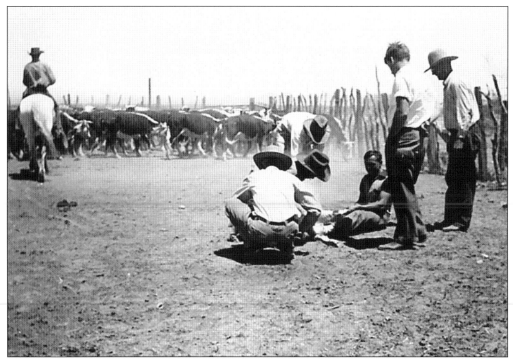

Branding young steers with the Sands "LS" mark in the 1930s at Manistee Ranch was a hot and dusty job for wranglers. Besides being used to raise crops, the ranch served as a feedlot to fatten cattle for market. Manistee Ranch was on the outskirts of Glendale until it was surrounded by a growing city. Half the ranch was sold off bit by bit in the years after World War II, but the rest was still used for ranching activities until 1996.

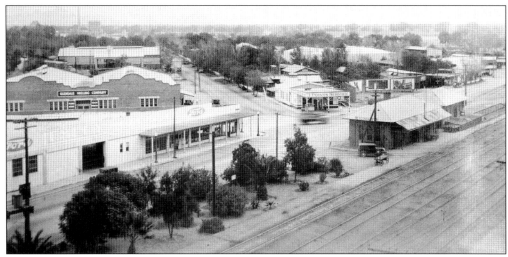

In 1930, the heart of Glendale centered on the all-important railroad tracks and Santa Fe depot visible in the right foreground of this image. On the left, across the street (Grand Avenue) from the trees, is Lemley's Ford dealership. Behind the Ford building is Glendale Milling Company, and behind that is Southwest Flour and Feed Company. On the left skyline is the faint image of the Sugar Beet Factory and its landmark smokestack.

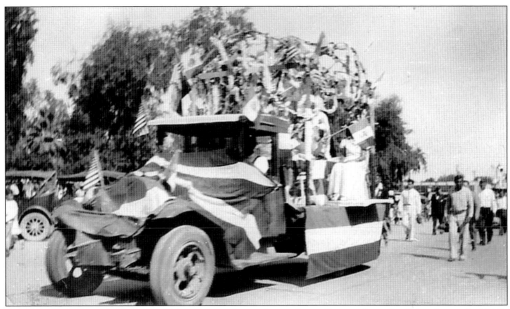

Fiestas Patrias, a celebration of Mexican independence from Spain, dates back to the early 1930s in Glendale and continues today each September. The celebration in and around the town park was a source of enjoyment for all of Glendale, not just the Hispanic community. A typical Fiestas Patrias would last two days and evenings, and it would include the crowning of a queen to reign over the colorful festivities, a parade (above), music, speeches, games, contests, and street dancing. Especially important were the food booths (below) set up in City Park, where, as the *Glendale News* put it, "real Mexican food was served." Although suspended for a time during World War II, the fiesta was reinstated in 1947 to the delight of people all over the Salt River Valley. These images are from the 1932 Fiestas Patrias.

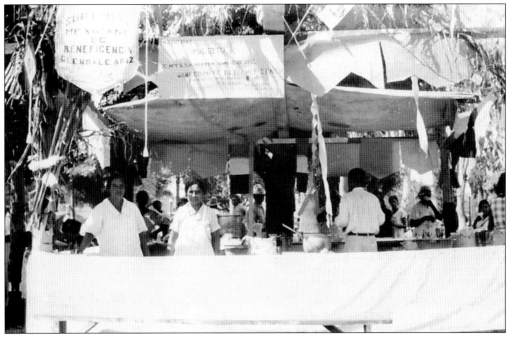

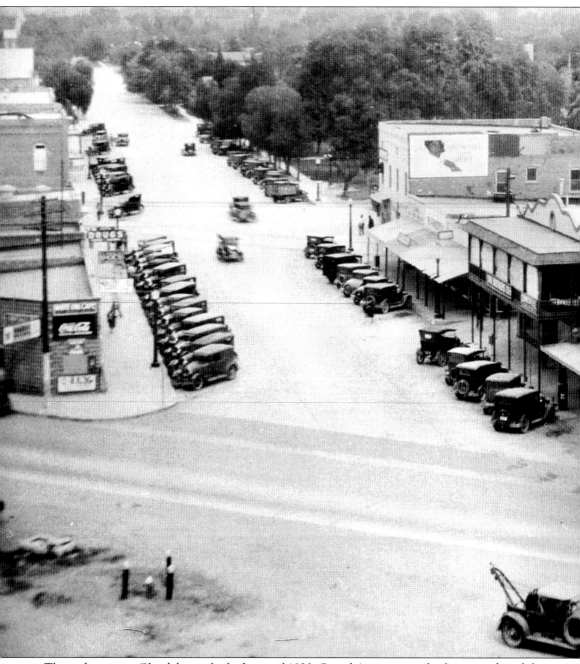

This is downtown Glendale as it looked around 1930. Grand Avenue is in the foreground, and the trees of City Park are seen beyond the buildings. In the middle of the park is a very tall flagpole.

Throughout Glendale's history, the park has provided a place to rest and relax and a location for community activities and celebrations.

Attorney Richard S. Gilmore checks out the taxi stand in front of the Ever Ready Drug Store in the Hine Building in the mid-1930s. Built in 1913 by investor Alice Hine, the structure was added to in 1919 to accommodate Beaty's Grocery. In 1928, Bill Betty opened the Ever Ready Drug Store in the corner store. By the 1940s, Ever Ready had been sold to Shel Neukom, who operated it for 25 years.

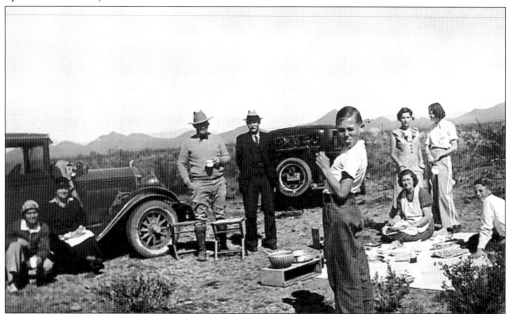

Picnicking on the desert was just as popular in the 1930s as it was in the 1920s. Around 1935, the Whitney and VanCamp families share a picnic excursion a few miles from Glendale. From left to right are Gladys Whitney, Maude Whitney (wife of Clarence), DeForest VanCamp, Clarence T. Whitney, Don VanCamp (sticking his tongue out), and Jean VanCamp (the wife of DeForest, sitting on the blanket).

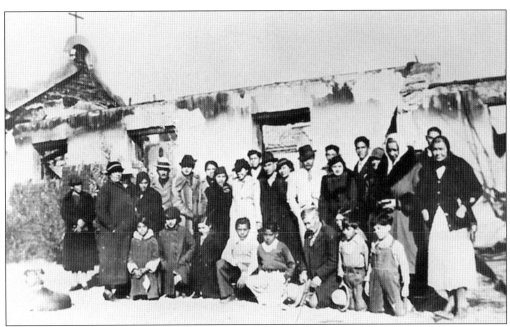

On Sunday, January 3, 1937, the small adobe Catholic Church in Glendale was destroyed by fire (above). The congregation, mostly Hispanic, was determined to rebuild their house of worship, but it would not be built of adobe, but stone. Black rocks were hauled by the congregants from the Salt River and the Black Canyon to build the new church. By the summer of 1937, the "Rock Church," as it was known locally, was ready for services, although the interior was not finished. The new church (below) was given the name of Our Lady of Perpetual Help. In 1953, the church acquired 11 acres of Manistee Ranch on which they built a school. Over the next 20 years, other buildings were added and finally a new sanctuary was built to replace the old Rock Church, which was abandoned and torn down.

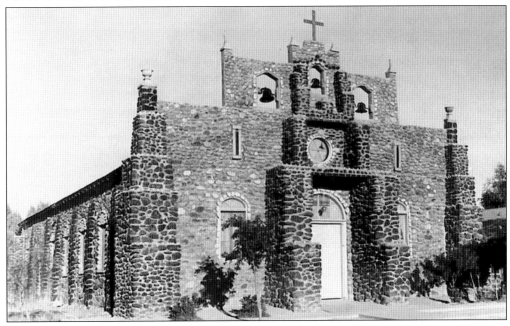

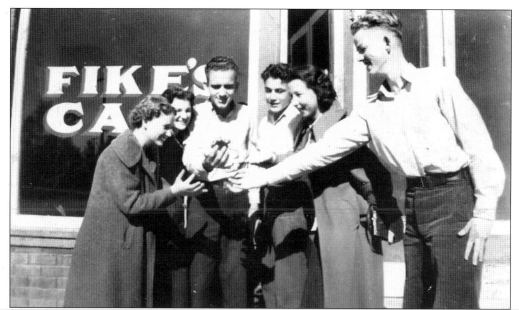

High school students often congregated after school in the late 1930s at a drug store soda fountain or café. Ezra Fike opened Fike's Café on Glendale Avenue in 1937. He had operated a number of cafés in Glendale and Phoenix over the previous two decades. The students laughing from left to right, are Madge Slack, Jeanne Ipharr, Pat Adams, unidentified, Ruth Sparks, and Dean Smith.

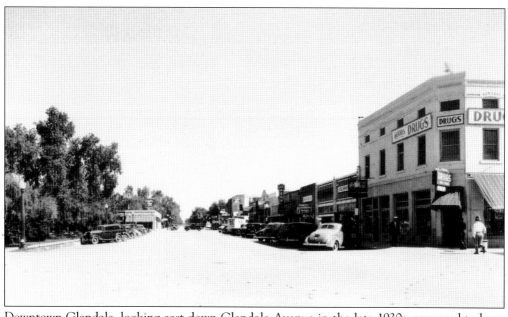

Downtown Glendale, looking east down Glendale Avenue in the late 1930s, appeared to have few parking spaces left for shoppers. On the right is the Gillett Building, which is housing Wood's Pharmacy. The trees on the left mark the south edge of City Park.

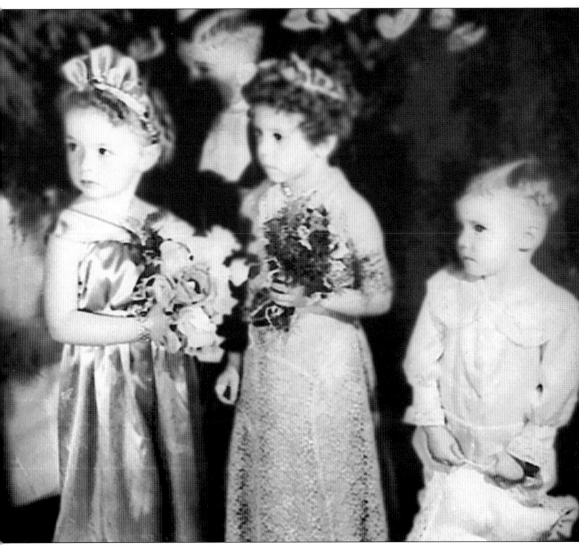

In "the good old days," entertainments were quite different: no television, no malls to cruise, and no rock concerts. There were movies (silent until the late 1920s), and beginning in the early 1920s there was radio. From time to time, there was a Chautauqua or a circus in town. In small towns such as Glendale in the 1930s, most entertainments were homegrown. A band gave concerts in the park, the Glendale Grays matched their skills with another baseball team, and everyone went downtown on Saturday night. In October 1938, the *Glendale Herald* reported, "The most fashionable and elegant wedding of the year will take place . . . at the Glendale Grammar School [today's Landmark School]. This Tom Thumb affair will be given by fifty tiny tots of the community." This play, a mock wedding, had a practical purpose as well as entertainment, as it raised money for the school's milk fund. Some of the Tom Thumb Wedding cast, from left to right, are Carol Coffelt (maid of honor), Nancy Stockham (matron of honor), and John Case (ring-bearer).

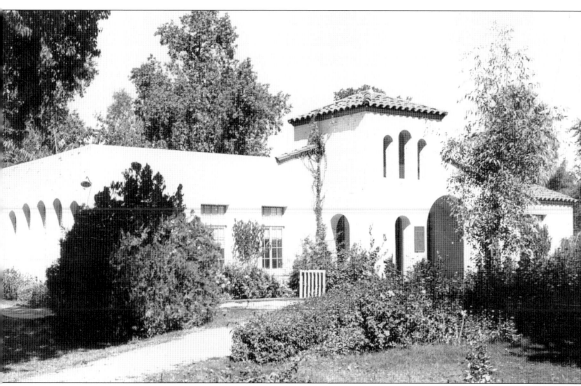

In 1938, Glendale's "Flagpole Library" was moved and became the American Legion hall. The library was a wooden building erected in the town park (Murphy Park) in 1917, encircling the town's single-piece, 110-foot wooden flagpole. A new, much larger brick library (above) was built in the park with Works Project Administration funds. The flagpole was not incorporated into the new structure but was moved and remained a prominent feature of the park until 1964 when it was replaced for safety reasons by a steel pole. The wooden flagpole had been fashioned from an Oregon tree and shipped to Glendale on three flatbed railroad cars in 1911. Originally intended for the Phoenix Y.M.C.A. grounds, the pole languished across from the Hotel Glenwood until 1912 because of the difficulty of moving it. Then Glendale acquired the pole, hauled it to the park with the help of the Sine Brothers, and erected it. The 1938 library was torn down in 1970 and replaced in 1971 by the current library building, the Velma Teague Library.

Four

THE MILITARY COMES TO GLENDALE

Glendale was profoundly changed during the years of World War II. Construction of Thunderbird Field and Luke Field, and their subsequent use as training facilities, brought thousands of people to the area. The people of Glendale opened their homes to the new arrivals to provide rental housing for them. Children were doubled up to make a room available and garages were turned into apartments. The town responded to the influx by growing into a city. School enrollment swelled to over 3,000, and by 1950, the city budget was ten times the $31,000 budget of 1940.

When Glendale went to war, the citizens left no stone unturned to protect the town. Local American Legion members and other civilian volunteers, after working their jobs all day, spent many a night with their hunting rifles and shotguns ready to ward off intruders at municipal facilities such as the sewage plant on west Glendale Avenue. The women of Glendale brought coffee, sandwiches, and other refreshments to these guards. But just like the men, even though everyone knew them, the women had to recite the night's password to be recognized as friend and not saboteur. The treatment of some, but not all, of the Glendale residents of Japanese ancestry is much less noble.

After the war, in 1945, Glendale tried to return to "business as usual," but times had irrevocably changed. Thunderbird Field became the site of the American Institute for Foreign Trade (now Thunderbird—The Garvin School of International Management). As the population grew, the city began to annex land to the north and west and integrate new construction with the existing city. When the Office of Price Administration expired in 1946, and with it price controls on most everything, there was the inevitable rise in prices. Few took notice, however, because there was so much pent-up demand for consumer goods and so much available in the postwar years: cars, washing machines, radios, televisions, and all those foodstuffs that so recently had been rationed. With growth came other changes. Traffic signals were installed on Glendale Avenue, Glendale's own radio station (KRUX) started broadcasting, a frozen food–locker plant was built, and a modern new theater (the Glen) opened. Another change was the closing of small family markets as grocery chains took over the business. By the 1950s, many Glendale pioneers had passed away, leaving the city to a younger and newer generation.

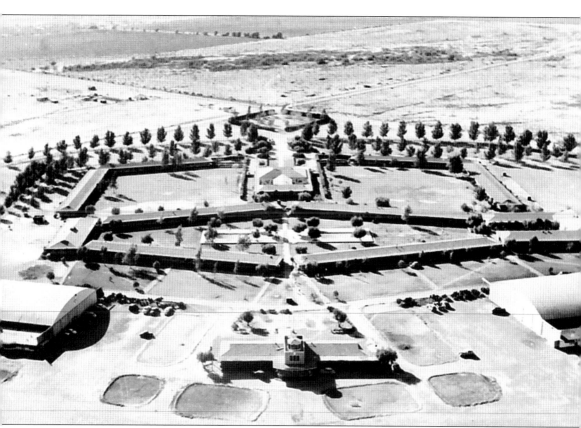

Construction of Thunderbird Field began in January 1941. The airfield was part of the U.S. Army's Civilian Pilot Training Program, whose goal was to increase the number of trained pilots in America in case the country became involved in the war raging at that time in Europe. Thunderbird was a civilian contract school operated by Southwest Airways and supervised by army air force personnel. The first class of cadets, 57 strong, arrived in March 1941. They received 65 hours of flying training and 109 hours of ground-school instruction over a period of nine weeks. After that, they may have gone on to more advanced training at another airfield. By the time Thunderbird closed in June 1945, over 10,000 men had trained there as well as 15 classes of Chinese Air Force cadets. The plane they learned in was the bi-wing Boeing PT-17, popularly known as the "Stearman." In this 1946 image of the field, the resemblance of the building layout to the Native American concept of the mythical thunderbird can be seen. At the bottom, the control tower forms part of the tail of the thunderbird.

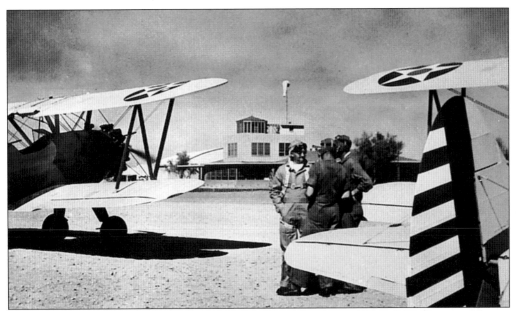

An instructor at Thunderbird Field checks out student pilots prior to takeoff. The bi-wing training planes, Boeing PT-17 Stearmans, were painted yellow with red, white, and blue tail markings. Known as "Thunderbirds," the planes starred in a 1942 motion picture *Thunder Birds: Soldiers of the Air*, with Preston Foster and Gene Tierney. The movie was filmed in, around, and above Glendale and vicinity.

Housing was not provided to civilian instructors or student officers at Thunderbird Field during World War II. Consequently, men such as instructor Bill Stedman had to find a room with a local family. Nearly every available room in the area was rented. This served the dual purpose of providing much needed housing for the fliers and extra income for the households. Stedman is standing in front of the Charles "Charlie" Pitts home, where he had a room.

In March 1941, the Del E. Webb Construction Company began excavation in the desert west of Glendale for the first building at Luke Field, now Luke Air Force Base. By mid-June, the first runway was operational and the first class of pilots was training. The field was named for Arizona's World War I ace pilot, Lt. Frank Luke Jr., who scored 18 aerial victories before being killed at age 21. The airbase was an advanced training facility, the largest fighter-training base in the Air Corps. Today it is still an advanced training base for F-16 fighters.

In the 1940s, Glendale welcomed travelers on Grand Avenue at its intersection with Glendale and Central (Fifty-ninth) Avenues with a large neon sign. To the right is Mac's corner, which housed the Greyhound bus depot as well as Mac's Corner Café. Across Glendale Avenue is Hearn's Second Hand Store, and further down the road is a Standard Oil station. Hearn's and Standard Oil gave way to the city's Municipal Office Complex in the 1980s. The sign was removed in August 1951, having lasted a scant dozen years.

Three of the Mondo girls and their friend have their pictures taken at the Mondo Farm in Glendale in the 1940s. John Mondo was born in the Punjab district of India in 1892 and immigrated to California in 1909. In 1934, he moved to the Glendale area and purchased 40 acres of land that formed the nucleus of his successful vegetable farm, which he operated until 1959. The girls, from left to right, are Jean Mondo, Margie Mondo, Helen Mondo, and Earline Smith.

Playing in an irrigation ditch or in the flood irrigation was one way to cool off when it was hot in the summertime. When there was no canal nearby, it was perfectly acceptable to take a dip in a large tub. Young Carleton Pitts, around 1939, is clearly enjoying his backyard "swimming pool."

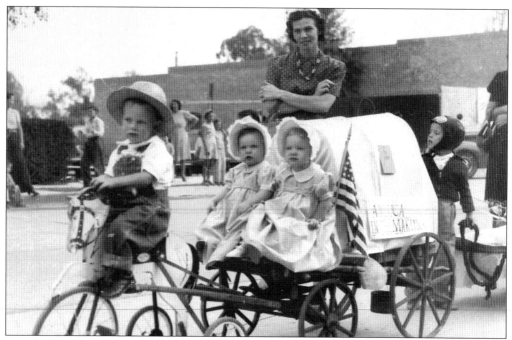

Everybody loves a parade. These children are honoring the pioneer spirit of Glendale with their covered wagon entry in a 1941 parade rolling east along Glendale Avenue. Watching over the youngsters is their mother, Opal Peck. The boy on the tricycle is William "Billy" Peck; the girls are twins, Martha (left) and Mavis Peck; and behind the pioneers' covered wagon, leading the next entry, is Dale Smith wearing an aviator's cap.

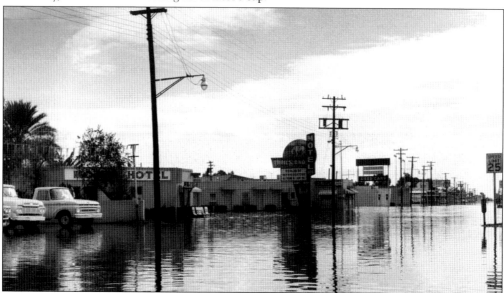

Glendale's first motel, the Kiser Motor Court on Grand Avenue, was built in 1940. Before it opened, a traveler would have to seek lodging in the Hotel Glenwood or go to one of the campgrounds or tourist courts. The Kiser family sold the motel in the 1950s and the new owners changed the name to Trail's End Motel. It was sacrificed to the Grand Avenue project in the 2000s. As this image shows, flooding on Grand avenue was a problem shared by many.

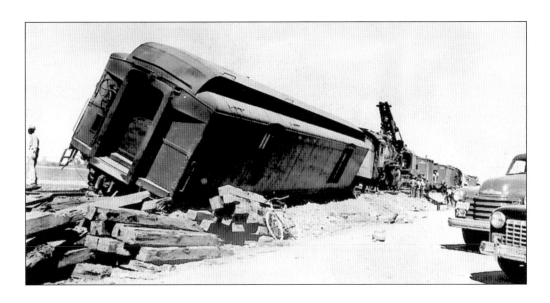

Glendale was not immune to train wrecks. In the 1940s, there was heavy rail traffic on the Santa Fe through town, which increased the likelihood of a mishap. The image above shows a rail-mounted crane at work lifting a derailed car just west of downtown. The image below records what usually happens when train and car meet—the car loses.

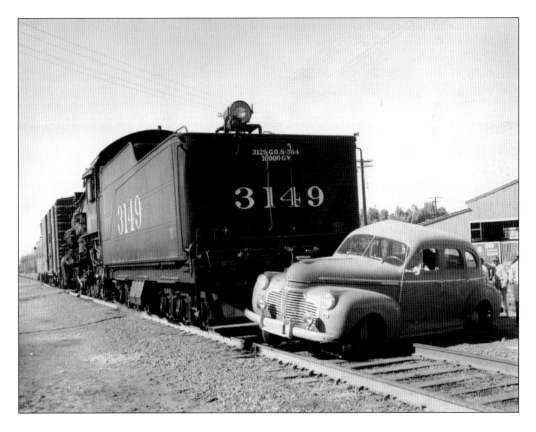

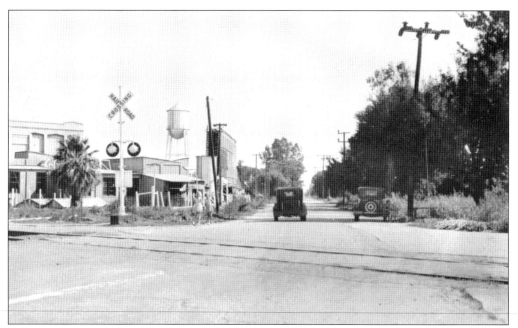

In the early 1940s, if one stood at the six-points intersection at Central, Glendale, and Grand Avenues looking south along Central (Fifty-ninth) Avenue, on the far left would be seen the Crystal Ice Company plant and the City of Glendale's water tower. On the right are weeds and tall grass along Lateral 18, an open ditch at the time. North of the intersection, townsfolk used wooden footbridges to cross the open waterway. After World War II, the lateral was enclosed.

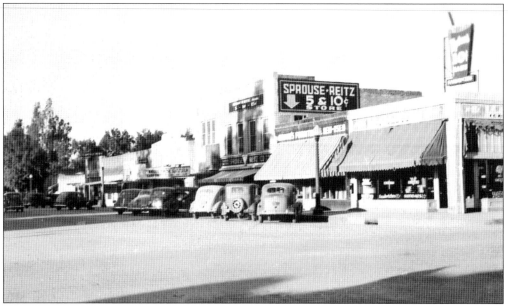

Upton's Ice Cream Parlor (corner store on right) was a popular place to go after seeing a picture show at the El Rey Theater, which was just a few doors away. In the 1940s, a popular waitress at Upton's was Marizona Baldwin. One of her loyal admirers told his friends that he was going to marry her some day. In 1948, Martin Robinson, better known as country music star Marty Robbins, did what he said he would. He married her.

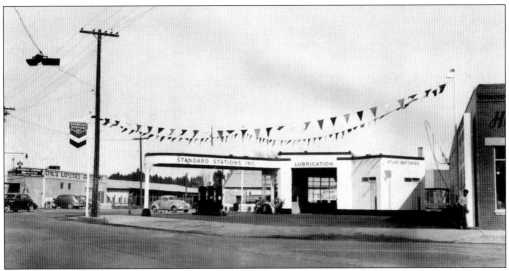

Throughout World War II and for many years after, the Standard station attendants dispensed less-than-a-quarter-a-gallon gasoline, changed oil, and lubricated cars. The station was located on one of the corners where Grand Avenue, Lateral 18 (Fifty-ninth Avenue), and Glendale Avenue intersect. The corner once was the home of one of Glendale's first service stations, the Ludden-Gillett Service Station. Today the Municipal Office Complex parking structure occupies the land.

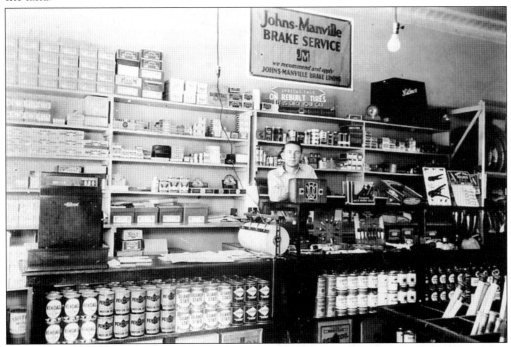

In the 1940s, Joe Whitney is behind the counter of the Brooks and Whitney Auto Parts store. Whitney started in business working for Ray Stauffer in his men's store. Later, with Victor "Vic" Brooks, he owned a Union Oil Station for a few years before the two purchased the Western Auto store in town. Along with the Western Auto store, the two partners opened their own auto-parts store across the street.

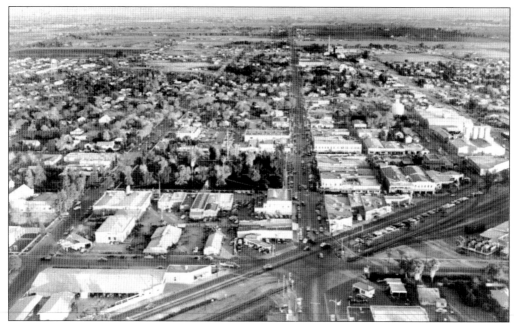

This is downtown in 1950 looking east along Glendale Avenue at the six-points intersection of Grand, Glendale, and Central (Fifty-ninth) Avenues. Grand and the Santa Fe railroad tracks cut diagonally across Glendale Avenue. Trees in the center delineate City (Murphy) Park. On the right are the warehouses and silos of Southwest Flour and Feed Company. The large building in the lower left, on Central Avenue, is O'Malley Lumber Company. The buildings in the block west of the park are gone, replaced in the 1980s by the Municipal Office Complex and parking garage.

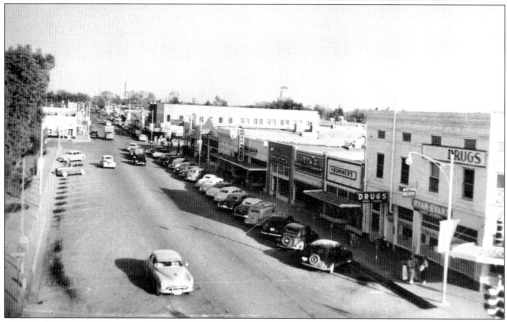

Pictured here is Downtown Glendale, looking east along Glendale Avenue, in 1952. On the right is the Gillett Building, which housed the Ryan-Evans Drug Store. On the left is the edge of City (Murphy) Park.

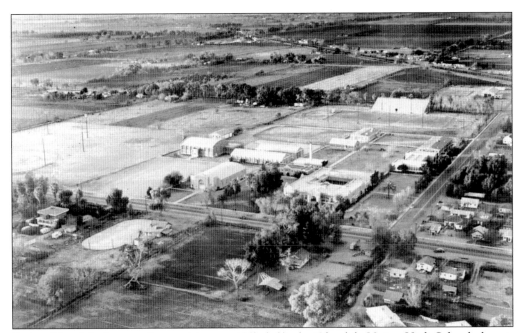

Facing Glendale Avenue (lower right to middle left), the Glendale Union High School plant is seen in the center of the image. Downtown Glendale is half a mile to the east (right). To the west (left) and in the distance are farm fields in this 1950 image. Today the fields are gone, having been turned into residential and business developments.

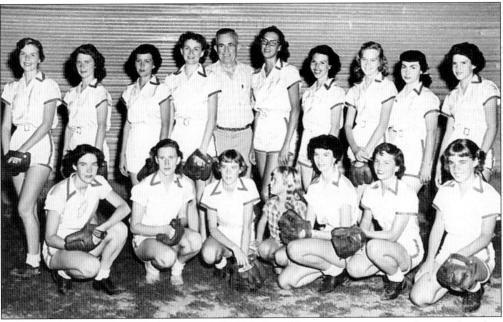

Girl's softball was popular in the 1940s and 1950s. Local businessmen sponsored teams that they frequently named according to their business. Thus when the Glendale Hatchery sponsored a team it was called the Chicks. The Chicks became Webster's when Webster's Creamery assumed sponsorship. Poston's Tillage sponsored the Sweethearts for several years. In July 1951, the undefeated Webster's team proudly poses for their picture.

In 1954, John F. Long began building a master-planned community on land south of Glendale. He named his development "Maryvale" after his wife, Mary Tolmachoff Long. He used mass-production techniques to construct thousands of houses over the years. In 1961, Glendale annexed 4.4 square miles of unincorporated Maryvale, thereby extending the city's southern border by one and a half miles and nearly doubling its land area and population.

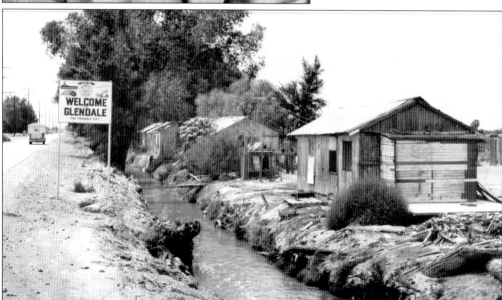

A typical earthen irrigation ditch flows past several run-down shacks on a farm at Olive Avenue and Lateral 16 (Forty-third Avenue) just outside of Glendale. These and other shacks like them throughout the Valley were used as temporary homes by itinerant farm laborers during harvest season. Living conditions were most primitive. Although the accepted norm in the 1950s, such accommodations are not tolerated today.

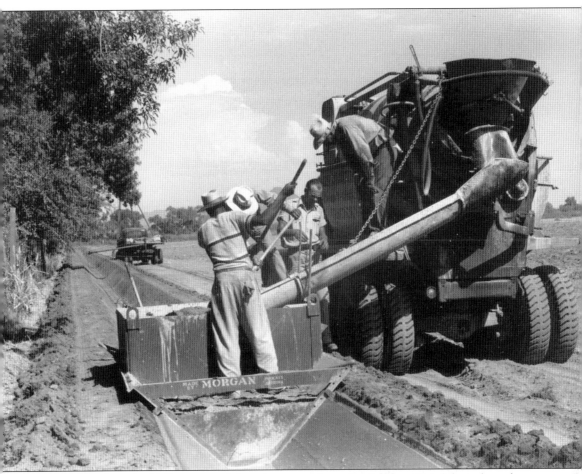

Irrigating fields in the Valley required diverting water from the Arizona Canal down laterals to irrigation ditches on the farm or ranch property. Early ditches were dug by hand. Later horse-drawn or tractor-drawn machinery was used to make ditches. The more-sophisticated ditches were lined with concrete. In 1950, on a farm west of Glendale, lining an irrigation ditch required several men and machines to complete the job. A lead truck pulled a "cement boat" that was supplied with concrete by a string of transit-mix trucks. The concrete flowed out the bottom and sides of the "boat" to line the earthen ditch. Once the ditch was in use, wood or metal check gates were used to control the flow of water into a field. Usually fields were watered once a month in the winter and twice a month in the summer.

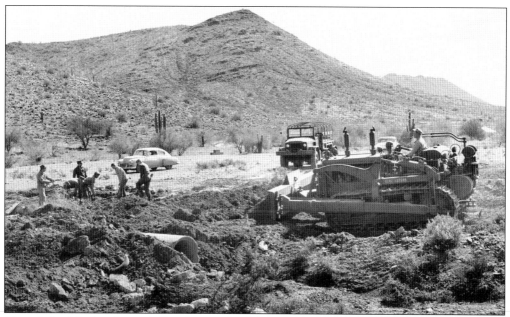

Thunderbird Park is located 10 miles north of downtown Glendale in the Hedgepeth Hills. It started as a 10-acre Glendale Woman's Club project in the late 1940s, but soon it mushroomed into a 1,000-acre park with plans for an amphitheater, picnic ramadas, hiking trails, and baseball diamonds. In 1952, the city leased the land from the U.S. Bureau of Land Management for 1.5¢ per acre per year. Over the next few years, the entire community, including volunteers from Luke Field (above), pitched in to develop the park. Road graders (below) improved access to the park, and picnic areas, hiking trails, and an amphitheater were built. In 1956, the Bureau of Land Management offered the parkland to the city for $3 per acre. The Rotary Club of Glendale took up the challenge to raise the money, which it did in a week's time.

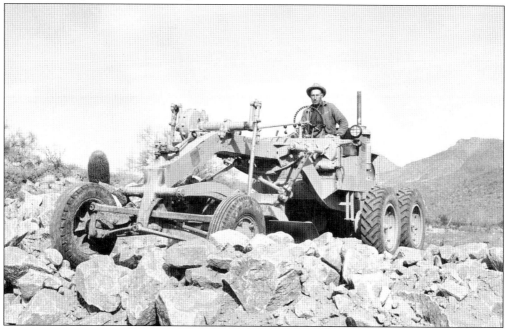

Five

URBANIZATION BRINGS CHANGE

As Glendale developed commercially, farmland yielded to subdivisions, shopping centers, and schools. Construction topped $1 million by 1952. In the 1950s, the speed limit on Grand Avenue was raised from 25 to 35 miles per hour, and Glendale's Patti Marks was chosen Queen of the Arizona Melon Festival (1955). The El Rey Theater closed in 1957 after 20 years of screening movies. Also, the post office moved to larger quarters twice, Canasta parties were popular, and a new Oldsmobile 88 two-door sedan was priced at $2,700.

Floods still periodically dampened downtown as they had since the town was founded, but they did not hinder the progress of Glendale. That progress included population growth, annexation of land into the city, building, and expansion of municipal services. Casualties of these changes were many of the old landmark buildings, such as the Hotel Glenwood, which was condemned in 1959.

Vestiges of an earlier Glendale are found in parades and celebrations, many of which had their roots in the early 1920s. The annual rodeo and parade was a weeklong event that ended with a World Championship Rodeo featuring 100 or more head of cattle and upwards of 50 bucking horses. In 1952, the parade "caravan" was led by Gov. Howard Pyle and sported homemade floats, horses and riders, bands, and others.

By 1960, nearly 16,000 people lived in Glendale. There were five elementary schools and four high schools, a paid fire department, a new sewer plant, a hospital, and the old Sugar Beet Factory was concentrating grapefruit juice for the Squirt Company.

The pattern of growth, annexation, and modernization that characterized Glendale in the 1950s also describes Glendale in the 1960s and 1970s. Population and budgets doubled and doubled again. With the Valley-wide renaming in 1962, Glendale's Central Avenue (also known as Lateral 18) became Fifty-ninth Avenue to conform to the new system. Other streets in many Valley cities were also renamed and, necessarily, house numbers changed. Some streets, however, such as Glendale Avenue and Grand Avenue, retained their historic names.

Not long after the street renaming, Glendale Community College acquired part of Sahuaro Ranch for their campus. It had been one of the earliest farming operations in the Glendale area, but changing times brought changing uses for the land. Other indicators of change were the 30,000-plus names in the telephone directory and the growing need for a larger public library to handle the ever-growing demands of residents.

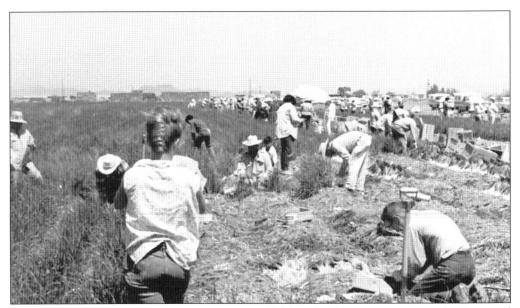

Eager hands harvest onions in a Tanita Farms field (above). The Naomasa Tanita family moved from California to Arizona in 1928 in a Model T Ford and by train. They lived north of Grand Avenue in 1941 when World War II started for the United States. In February 1942, President Roosevelt signed Executive Order 9066 authorizing mandatory evacuation of all persons of Japanese ancestry from areas in the West near military bases. The nearness of Luke Field to Glendale resulted in some evacuations. Grand Avenue was chosen as the boundary between those (north of Grand Avenue) who could stay and those (south of Grand) who were sent to the relocation camp in Poston, Arizona, for the duration of the war. The Tanita family stayed; nevertheless, six Tanita sons served the United States in World War II. The sign (below) points the way to the Tanita Farms packing and shipping docks north of the Santa Fe railroad tracks.

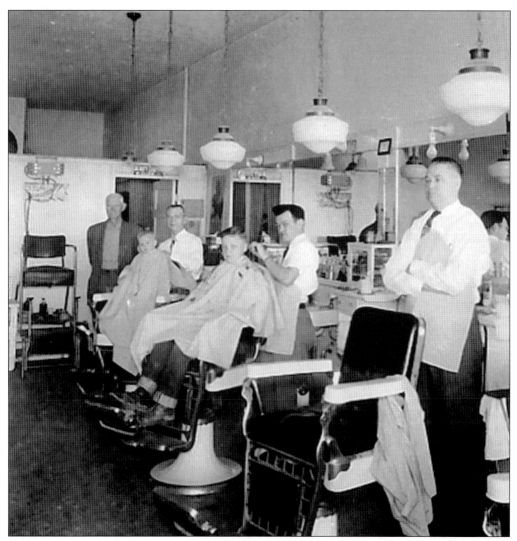

From its founding, almost every town had at least one barbershop, several if it was a town of any size. Glendale was no exception. Many shops came and went, but a few stayed for decades. One was Marshall's Barber Shop. Phil Marshall and his brother Joe were barbers in Kansas before coming to Glendale in 1930. Phil purchased Walters' Barber Shop from Verne Walters, and the brothers started shearing and shaving. Their shop in the early years provided public showers and bathtubs for patrons. And they always maintained it as a place to discuss politics, family matters, and community news. Phil retired in 1968 and Joe in 1989. The image is Marshall's Barber Shop in the 1940s. On the left is Sam Stoddard, grandfather of Barnes Twitty, who is being trimmed by Phil Marshall. The other patron and barbers are not identified.

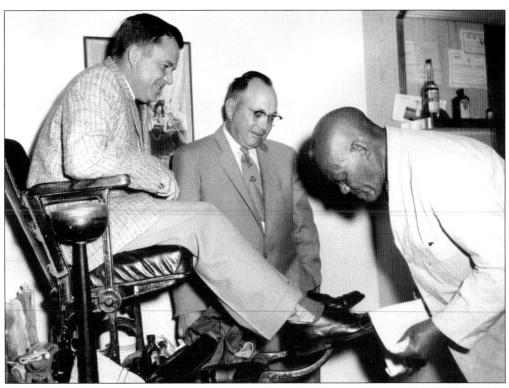

In earlier times, every good barbershop had a shoe shine stand or chair. In those days, shoes were made of leather and responded well to waxes and buffing. Billy Jack, head of Glendale's Valley National Bank, watches Sam put a high shine on a friend's wing tips in the 1950s.

Only a distant memory today, 23¢-per-gallon gasoline was the going rate in the 1950s. And when there was a price war, gas was even cheaper. This sign on Grand Avenue at Lateral 18 (Fifty-ninth Avenue) announces the day's price.

The E. L. Gruber Company (above) came to Glendale in December 1954. It was a manufacturer of knit underwear, the men's briefs and T-shirts sold in J. C. Penney stores. In 1960, J. C. Penney himself visited the Gruber Company and the local Penney store to see their operations. Gruber was Glendale's largest employer in the 1960s with more than 300 employees. Inside the plant (below), more than 100 women, each at a sewing machine, stitch the knit fabric together. Later Gruber's became the Spring City Knitting Company, but it closed its doors in 1992. Purchased by the City of Glendale, the building today is used as a storage center for the city.

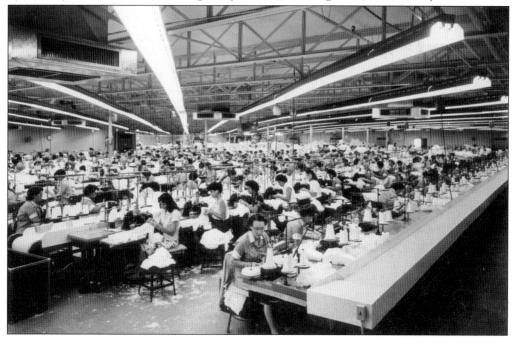

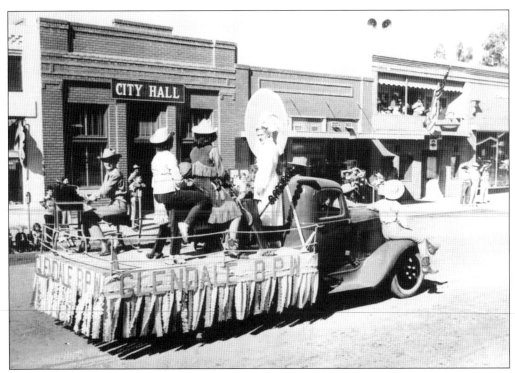

For years, the Glendale Lions Club sponsored an annual weeklong rodeo and parade. Included was a "jail" in City Park to incarcerate those who were not properly attired in Western wear. (A person could buy his or her freedom for 25¢.) One of the unique activities the first few years was local attorney Jay Sigworth's Gila Monster Derby. Of course, there was a parade. In 1952, it was led by Gov. Howard Pyle and sported a variety of homemade floats, including this one entered by the Glendale Business and Professional Women's organization (above). Among those riding on the float were Madge Ulrich, manager of the Glendale Mountain States Telephone and Telegraph Company Office; elementary school nurse Hope Ketcham; and city employee Volene Stockham. During the festivities, a queen and her attendants presided over all events, including the bronc riding (below), which in this case just ended in favor of the horse.

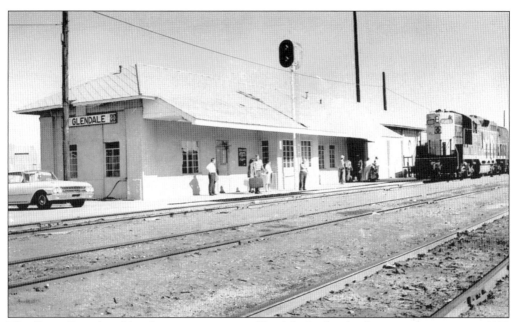

The Santa Fe railroad has been important to Glendale for freight-shipping services since 1895 when it first came to town. For many years it was also important for the passenger services it provided. Many a journey started or ended at this depot seen here in the 1950s. Built around 1910 to replace the original wooden depot, this depot was torn down in 1967.

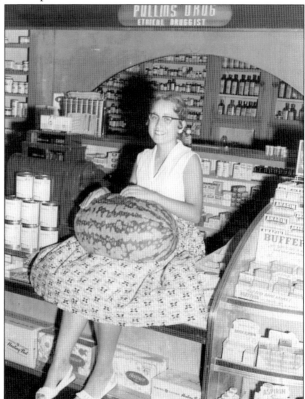

Watermelons have long been a favored crop among Glendale melon growers. In the 1950s, a popular summer event, the melon festival, drew crowds in the tens of thousands to Glendale to celebrate Arizona-grown melons of all types. Glendale watermelon and vegetable grower Rala Singh was so proud of his 53-pound watermelon that he took its picture.

Patti Marks of Glendale won the coveted title of Arizona Melon Queen in June 1955. Here she poses in the midst of a Valley melon field that is part of some 30,000 acres devoted to melon crops. Melons were a big business locally for many years. One of the duties of the queen was to promote Arizona-grown melons in the East, including Washington, D.C. Marks presents a honey-dew melon to vice president Richard Nixon (below) while most of Arizona's congressional delegation looks on, from left to right, that includes Rep. John Rhodes, Sen. Carl Hayden, Nixon, Marks, and Sen. Barry Goldwater.

Movie star Jeff Hunter (center) took time out from filming in January 1957 for a lube and oil change at a local garage. Twentieth Century Fox used Glendale's downtown as the setting for *The Way to the Gold* starring Hunter and Sheree North. Although normal business and routine in the city was disturbed to a certain extent by the movie making, the consensus of Glendalians was that it was a great event.

Santa arrived by helicopter to the streets of Glendale in December 1957. Just after Santa "hit the ground," hundreds of children rushed up to get a candy treat from him. Santa's appearance was sponsored by the Glendale Auto Show and Dollar Days. The helicopter was provided by Blakely Service Stations. They were popular for their inexpensive gas and free drinking glasses (with purchase) with Arizona themes. Blakely's and the glasses disappeared after 1967.

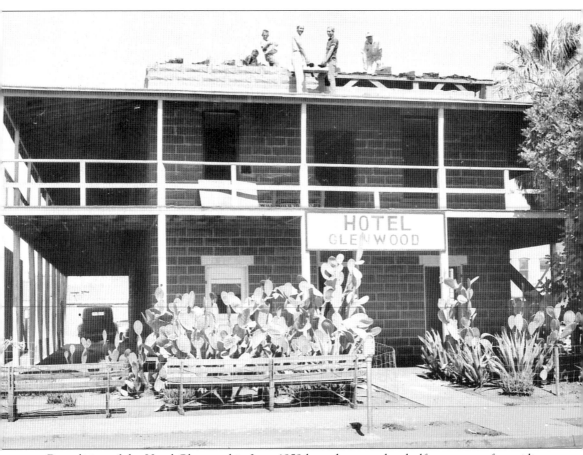

Demolition of the Hotel Glenwood in June 1959 brought an end to half a century of providing sleeping quarters to travelers, laborers, and others and cleared the way for a parking lot. Declared a health and fire hazard, the 22-room hotel was condemned by the city council. Built in 1909 or 1910, the Glenwood was owned and managed by Archie W. Bennett, Glendale's first mayor. The electric trolley line from Phoenix to Glendale ended in a turn-around near the hotel. It was not uncommon for Phoenicians to ride the trolley to Glendale, sit on the Hotel's porch "for a spell," and then return to Phoenix. The Glenwood's wide porches were often used as sleeping porches during the hot times of year, and sometimes they were "overflow rooms" when there were more guests than rooms. After the Park Hotel burned down in 1912, the Glenwood was the only hotel in town. Some rooms were available above a store or two, but they were few. Gradually over the years, the hotel slipped into disrepair. Finally, it was condemned as unsafe.

In January 1961, at age 77, Charlie Juncker retired after 49 years of practicing his trade in Glendale. Juncker was an expert blacksmith, specializing in electric and acetylene welding and building "any and all tools for machine or farm." When he retired, he turned his shop over to his son August. By then, the blacksmithing business had changed as there no longer were horses to shoe or wagons to build.

Glendale city manager Stan Van de Putte (center) accepts a new 50-star flag from Mrs. Gene Harris (left) and Mrs. Robert Ryan, representing the Glendale Elks Lodge Dears. The flag was displayed in remembrance of Armistice (Veterans') Day, November 11, 1960. For 22 years, beginning in 1960, Van de Putte served as city manager. During his tenure, Glendale matured from a farming community of 16,000 to a multifaceted city of more than 100,000.

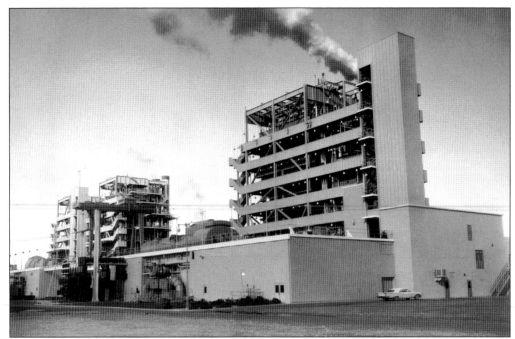

Northwest of downtown Glendale, at Lateral 20 (Seventy-fifth Avenue) and Northern Avenue, the Salt River Project built a 596-megawatt electric generating plant, the Agua Fria Steam Generating Station. It was brought on line in 1957 and has served the area well since then.

Over many years, Glendale mounted unsuccessful efforts to build a hospital. Finally, in 1959 Mayor Byron Peck headed a successful effort to bring a hospital to Glendale. The 62-bed Northwest Hospital was built on the corner of Sixty-first and Northern Avenues. The first patients were admitted in 1960. Later it became part of the Good Samaritan system of hospitals. Today the building is no longer a hospital but is occupied by the Salvation Army.

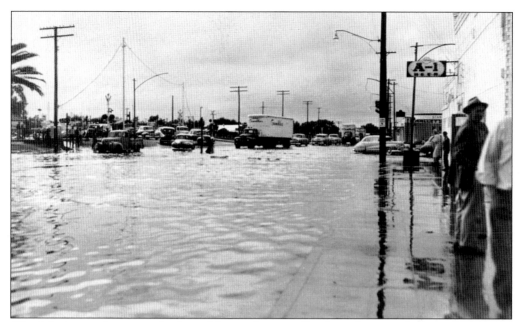

Glendale from its beginning had a problem with streets flooding whenever there was heavy rain. Lacking adequate storm drains, streets remained flooded for days. Part of the problem was that the railroad bed effectively dammed water to form "Lake Grand" downtown. This is the flooding of Grand Avenue near the six-points intersection with Lateral 18 (Fifty-ninth Avenue) and Glendale Avenue in 1957. The Santa Fe tracks are on the left, parallel to Grand Avenue.

Glendale Community College was established in the early 1960s on 120 acres of Sahuaro Ranch. Opened to 2,000 students in 1965, its enrollment has increased to where it stands today at well over 36,000. The college offers university-transfer programs, job-related programs, and non-credit training customized to specific business needs. Its commitment to technology-enhanced learning has enabled the school to meet modern needs.

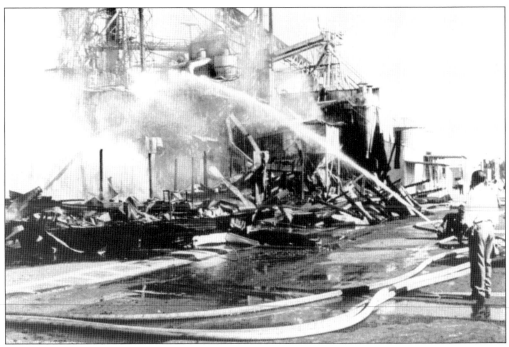

A fire on May 16, 1967, destroyed the plant, warehouse, and offices of Southwest Flour and Feed Company. In some respects the fire was beneficial to the business because it eliminated the outdated technologies of the old mill. Under the guidance of Harry Bonsall Jr., Southwest Feed and Seed Company erected a new, high-capacity electronic mill. Although they built another mill and warehouse in a different location, the Bonsalls never replaced the fire-destroyed Southwest Flour and Feed Company plant. Harry Bonsall Sr. never quite recovered from the shock of the fire that destroyed what he had built up over a 50-year period of time.

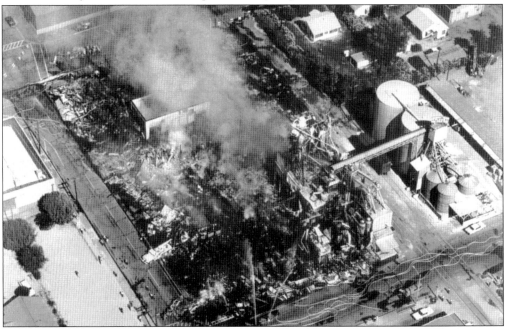

In the 1950s, many young men found summer jobs icing rail cars on Crystal Ice Company's siding in downtown Glendale (above). Blocks of ice weighing 300 pounds were sent on a conveyor belt along the icing deck and then loaded with pointed, hooked pikes into icebox rail cars. About five and a half tons (11,000 pounds) were required to chill each car. By 1959, a giant icing machine (right) replaced the men with pikes to load the ice compartments of some 150 cars daily during harvest season. Using ice to keep produce cool as it traveled to distant markets declined in the 1960s in part because of the introduction of mechanical temperature-controlled refrigerator cars to the rolling stock of the Santa Fe Railway.

In the 1950s and 1960s, the demand for ice declined as agricultural lands were turned into urban areas and mechanically refrigerated rail cars and 18-wheelers assumed the task of transporting cooled produce. By the 1970s, the giant ice warehouses at the Crystal Ice plant in Glendale were nowhere close to being used to capacity. Indeed, on the evening of March 27, 1972, both warehouses were empty when an explosion and huge fire broke out in one of the warehouses. Soon the other one was burning, and both warehouses were destroyed. An estimated $500,000 in damage was done to the plant, including the collapse of two walls of one storage building. Seventy-five firefighters and 10 units from Glendale, Phoenix, and Luke Air Force Base fought the fire into submission over an 18-hour period. This was the beginning of the end for the Crystal Ice plant in Glendale. A second round of fiery destruction occurred in September 1972, only six months later. Today the ice-plant grounds are vacant.

When Dial-A-Ride came to Glendale in 1975, the mayor of Glendale (above) was among the first to try out the new service. The passengers, from left to right, are Betty Klass, Mayor Max Klass, and three unidentified riders. Klass served as mayor for 10 years from 1966 to 1976. During his tenure, the population of Glendale grew by 42,000 and the incorporated area of the city increased from 14 to 22 square miles. Part of Glendale's new fleet of Dial-A-Ride buses gears up for the day's work (below).

The Thunderbird International Balloon Race began in 1975 to raise scholarship money for the American Graduate School of International Management whose campus was the old Thunderbird Field. In the 19 years that Glendale hosted the race, it became one of the top hot-air balloon races in the country. By 1989, it had grown so large that the campus could no longer accommodate the number of entries. The race had to lift off from Glendale's airport.

Six

TRANSFORMATION INTO A MODERN METROPOLIS

Approaching the end of its first century in the late 1980s, Glendale had become Arizona's fourth-largest city, up from fifteenth in the 1920s. With a population nearing 150,000, the need for all manner of new and/or improved infrastructure and services was clear. City facilities and buildings were inadequate to the needs of its citizens. In the process of bringing the city "up to snuff," the small-town police station of the 1950s first gave way to a larger facility and then in 1991 to a new facility, the Public Safety and City Court Complex. The new quarters were a far cry from the days when "Dad" Rudd was the only law enforcement in town. City hall was also hard pressed to meet the growing needs of the city. Thus, in the early 1980s, construction of a new municipal complex got underway with the demolition of the old buildings on the block adjacent to City Park on the west. At the same time, the historic downtown area was undergoing its own transformation, as it was becoming more tourist-oriented with its various activities in the park and opening of new eateries and antique emporiums.

Other additions to the city are equally noteworthy. The municipal airport was built in 1986, the Brown Street Library opened in 1987, and Sahuaro Ranch, newly acquired by the City of Glendale, was dedicated and opened for tours conducted by the Glendale Arizona Historical Society. Two fire station facilities were built, many new schools were opened (including Arizona State University West), and Murphy Park (formerly City Park) was renovated. Glendale's pride and joy in 1960, the Northwest Hospital (later Glendale Samaritan Hospital) disappeared and in its stead on Thunderbird Road was erected the nearly 300-bed Thunderbird Samaritan Medical Center. A few years later, Arrowhead Community Hospital and Medical Center was added to Glendale's medical facilities on the north side of town. Industry too came to Glendale. Early and particularly notable was the Sperry Corporation, which through mergers evolved into Honeywell. With the addition of parks, sewage plants, a landfill, and two water-treatment plants, the city was able to serve the needs of its citizens, businesses, and governmental entities.

From its initial one square mile of area, Glendale by the end of its first century in 1992 had grown to some 52 square miles of area. And it had grown from an agricultural town into a diverse metropolis.

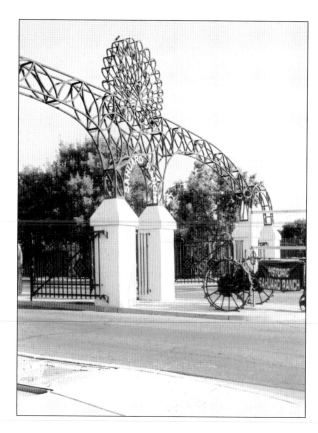

In 1977, the City of Glendale purchased the last 80 acres of Sahuaro Ranch from its owners, Richard S. Smith and family. Seventeen acres, containing most of the old ranch buildings, were set aside as a historic park. In the 1980s, an elaborate entrance gate to the park was built and restoration of the buildings started. Often dubbed the "Showplace of the Valley," Sahuaro Ranch offers guided tours provided by the city and the Glendale Arizona Historical Society.

By the early 1980s, Glendale's city hall had expanded into three remodeled buildings to the west of City Park on Fifty-eighth Drive. These quarters, however, were overcrowded and inadequate to the needs of the fast-growing city. Thus was born the idea of building the Municipal Office Complex, which was completed in 1984.

A new city complex takes shape (right). The American flag indicates that the steelworkers have "topped-out" the steel framework for the six-story Municipal Office Complex, opened in 1984. Behind that building, a four-story parking garage was erected. Today the complex (below), generally referred to as "city hall," stands tall in the historic downtown area with other modern buildings and many restored decades-old survivors of Glendale's earlier days. The complex was designed by Glendale architect Robert Sexton. There was much debate about where to locate the new city hall. Would it be in the fast-growing northern part of the city, or downtown in the historic center of the city? Downtown won the debate.

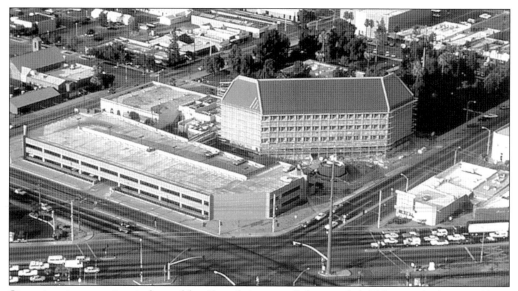

Six-points intersection is formed by Grand Avenue (left to right), Fifty-ninth Avenue (from bottom to left side), and Glendale Avenue (bottom to right side). The new, six-story (two below ground level) city hall and parking garage appear prominently in the center of the image. The three buildings comprising the old city hall are left (north) of the new building. Old city hall was demolished in order to build the meeting rooms and amphitheater of the new Municipal Office Complex.

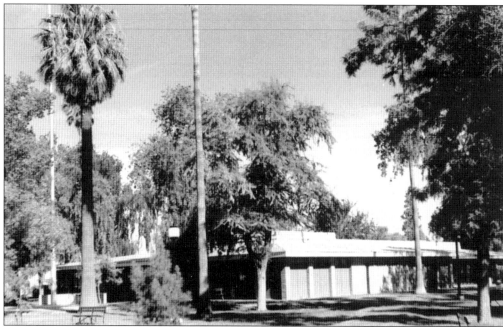

The Velma Teague Library, named in honor of Velma Teague who served Glendale as librarian for 30 years, was completed in 1971. It was the third library building located in City Park. The 1917 library was torn down in 1938 to make way for a new and larger library. It was torn down in 1970 and replaced by the larger, modern Velma Teague Library. On the left is the 100-foot steel flagpole that replaced the park's record-setting 110-foot wooden flagpole in 1964.

Mayor George Renner (left) and two unidentified officials dig the first shovelfuls of dirt on the site of the Bank of America Building in 1986. To have room for the large structure, an entire city business block was leveled. Some businesses relocated, while others simply "retired." In the background is the Methodist Church, which was completed in 1928.

The businesses and professional offices north of Murphy Park were casualties of urban renewal in 1986 when they were razed to make way for the modern Bank of America Building. It was Glendale's first Class-A office building. Standing in the heart of downtown, across the street from the 80-year-old Methodist Church and across the park from an entire block of historic old storefronts, this building exemplifies Glendale's successful mixing of the new with the old.

Until the 1980s, Glendale had only one public library. It was in Murphy Park where it had been for decades. But the needs of a growing population were outstripping the library's ability to provide services. In response, a new main library, located on what used to be a part of Sahuaro Ranch, was completed in 1987, pictured here. The old library became a branch library. By the 1990s, it was clear that another library was needed. In July 1999, the Foothills Branch Library opened.

A bronze statue of territorial lawman Sam Stout was installed in the courtyard of the Glendale Public Safety and City Court Complex in 1991. Stout worked as a foreman during construction of the Arizona Canal and later homesteaded land in the Glendale area. For a time, he was an Arizona territorial sheriff. Stout claimed that he killed 85 rattlesnakes one night during irrigation of his farm.

Seven

A City on the Move

Established first as an agricultural community, Glendale grew into a multifaceted city with a diversity of peoples, vocations, and pastimes. Today, well into its second century, Glendale is a vibrant city on the move. Its forward-looking mayors and city council have led the city in planning for the future in housing, shopping, recreation, parks, and economic development. Starting in 1993, Arrowhead Towne Center in north Glendale has grown to over 170 shops, restaurants, and other businesses. At the same time, the 4,000-acre Arrowhead Ranch housing development began to exchange ranch land for home sites. In 2002, just north of the historic downtown area, a modern new mall, Northern Crossing, began to rise on the cleared site of Valley West Mall (later called Manistee Town Center), Glendale's first mall.

As the face of Glendale changed and the downtown was revitalized, there was a kind of continuity from old to new. Downtown Glendale still has a small-town feel. Its shops, small restaurants, special events, and festivals connect the present with the past. Historic Catlin Court, with its restored residential bungalows and bungalows-turned–specialty shops, provides a glimpse back in time when life seemed to move at a slower pace.

Change is ever-present in Glendale. Dozens of master-planned developments and infill housing subdivisions have sprung up, as have business parks and mini-malls. Elementary schools and high schools dot the city, and higher-education institutions have found homes in Glendale.

A growing number of multiuse facilities are sprouting up. The Glendale Civic Center opened in 1999, the Glendale Arena in 2003, and the Arizona Cardinals Stadium in 2006. Accommodating up to 1,300 people, the civic center in downtown Glendale hosts weddings, reunions, graduations, collector's shows, and conferences. In the western part of the city, the Glendale Arena is home to the National Hockey League team the Phoenix Coyotes. It is also a major concert venue, having featured headline performers such as Paul McCartney, Madonna, and U2. Across the street from the arena, the Arizona Cardinals Stadium, home to the 2008 Super Bowl, is considered by many to be the best stadium in the National Football League. Its retractable roof and moveable playing field are unique features of the stadium.

Adjacent to and complementing the West Valley sports facilities is Westgate City Center, a massive mixed-use development including office, retail, entertainment, restaurant, hotel, and residential uses. North of Westgate is the Zanjero development. It includes a Cabela's superstore, the world's foremost outfitter of outdoor and sporting gear.

Glendale of today is a far different place from Glendale of yesteryear, but Glendale cherishes its heritage and pays homage to it by conscious efforts to preserve the past.

This recent view from inside the Sugar Beet Factory shows that it is just a steel-and-brick shell. Its inhabitants are birds, bugs, and rodents. Although a number of attempts were made in the 1990s and 2000s to develop a plan for restoration of the building, no one has succeeded in offering a workable plan to convert the building to a useful community asset.

Located on a part of what was Sahuaro Ranch, Glendale Fire Station 157 prominently displays one of Glendale's many public artworks. Completed in 1997, the 20-foot-long brick sculpture by Jay Tschetter is a tribute to Glendale's firefighters and their heritage. Glendale's public art program was started in 1983. A small percentage of the cost of building city-owned facilities is used to purchase public art. The citizen-guided Glendale Arts Commission selects the art.

Glendale's first civic center, which opened in 1937, was located in a building converted from a car dealership. The second civic center (above) was built on north Fifty-eighth Drive. It was torn down to make way for the Bank of America building in 1986. Glendale's third civic center (below) opened in December 1999 with a millennium New Year's Eve party to usher out the 20th century and usher in the 21st century. The center took form as the result of a city council study that concluded the city needed space to hold banquets, weddings, conferences, and trade shows. Its presence has changed the face of downtown Glendale and led the way to the ongoing renewal of the old city center.

Glendale Arena, built to accommodate the Phoenix Coyotes, a National Hockey League team, opened with a full house of fans on December 27, 2003. Shortly, however, a yearlong suspension of play due to contract differences chilled the spirits of fans and arena managers. But since the arena was designed as a multipurpose venue, in no time at all the seats were filled time and time again by hosting the best concert performers of the day.

After more than 100 years of traffic problems at the six-points intersection of Grand, Fifty-ninth, and Glendale Avenues, construction to help solve the problems was started in 2005. The Grand Avenue underpass was completed in the summer of 2006, including pedestrian bridges, new lighting, and most importantly, pumps to drain away any rainwater that might accumulate. This image is looking west from city hall along Grand Avenue.

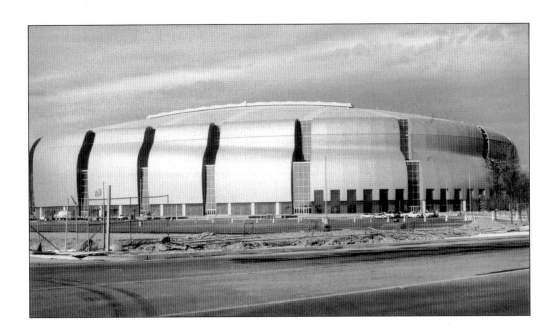

The exterior design of the National Football League's Arizona Cardinals Stadium was created by world-renowned architect Peter Eisenman. The basic form is modeled after a barrel cactus, quite appropriate for a desert area. The stadium has a translucent fabric roof that affords an open, airy feel to spectators. The natural-grass playing field is grown on a moveable tray measuring 234 feet by 400 feet. It remains outside the stadium in the sun until game day. In this way, the grass is in better condition than if it were grown inside. A 65-minute ride positions the grass inside the stadium. Another advantage of this system is that it provides unrestricted access to the stadium floor for events other than football.

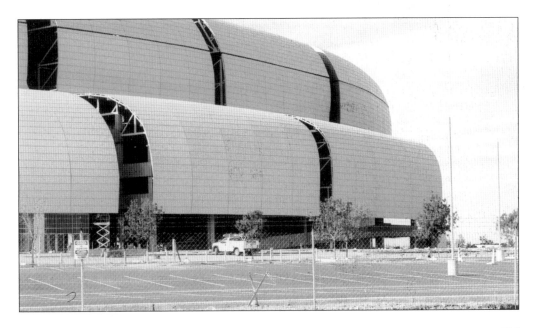

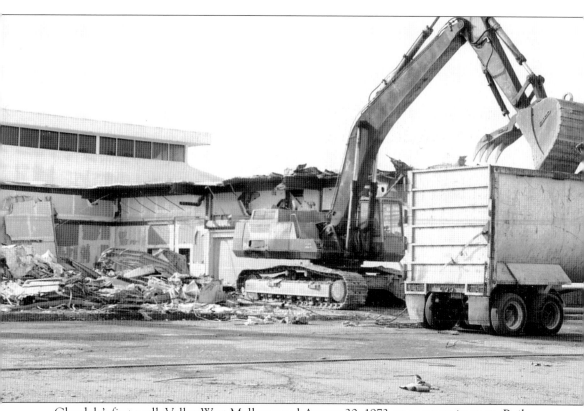

Glendale's first mall, Valley West Mall, opened August 30, 1973, to great excitement. Built on a part of the original Manistee Ranch a mile north of downtown, the mall was a status symbol for Glendale. It said that this was a community on the move, forward looking, and in step with the modern world. The mall brought new stores and restaurants, but as more businesses relocated into the mall, downtown Glendale was changed. Anchors in the new mall were Montgomery Ward and J. C. Penney. The mall boasted having a three-screen theater. It is interesting to note that downtown's Glen Theater closed for good at this time. On the east end of the mall was the Boston Store. Glendale's family-owned Boston Store (unrelated to the national chain) became Daou's down on Glendale Avenue. In 2001 and 2002, the "new" mall (that had been renovated and renamed Manistee Town Center in 1996) was razed to make way for another new mall, Northern Crossing. Slowly but surely the old buildings were reduced to dust.

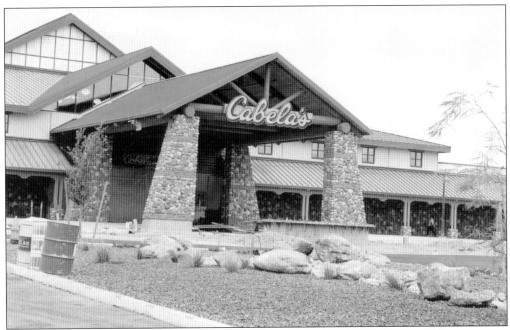

Just north of Westgate City Center, Glendale Arena, and Cardinals Stadium, on what was recently an alfalfa field, is Cabela's megastore. It is a 160,000-square-foot building that houses the most unusual combination of wildlife museum and retail outlet found anywhere. Cabela's, headquartered in Sidney, Nebraska, is a marketer of hunting, fishing, camping, and related outdoor merchandise. At its retail stores, such as Glendale's, it also has stuffed wildlife displays, a walk-through 40,000-gallon freshwater aquarium, and a salute to wildlife conservation.

AFTERWORD

The story of Glendale as told in this volume is one of change, growth, and development. Changes in the community from one day to the next are almost imperceptible. There is a sameness from day to day and from year to year. However, viewed over a 10-year or 20-year period, change may seem dramatic. Change is a slow, evolutionary process of building on the past. This brief story of Glendale's past should provide windows to understanding how Glendale developed from a small farming community to become what it is today, a large metropolitan city.

ACROSS AMERICA, PEOPLE ARE DISCOVERING SOMETHING WONDERFUL. THEIR HERITAGE.

Arcadia Publishing is the leading local history publisher in the United States. With more than 3,000 titles in print and hundreds of new titles released every year, Arcadia has extensive specialized experience chronicling the history of communities and celebrating America's hidden stories, bringing to life the people, places, and events from the past. To discover the history of other communities across the nation, please visit:

www.arcadiapublishing.com

Customized search tools allow you to find regional history books about the town where you grew up, the cities where your friends and family live, the town where your parents met, or even that retirement spot you've been dreaming about.